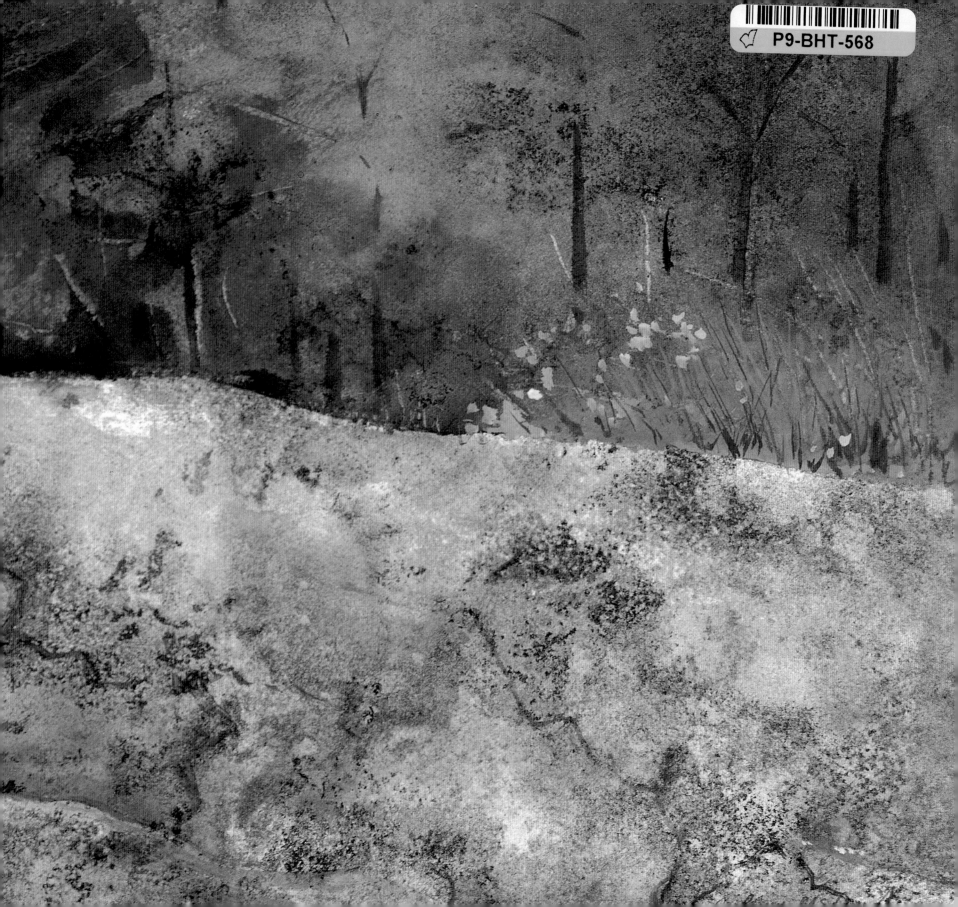

John W. McCoy
American Painter

John W. McCoy
American Painter

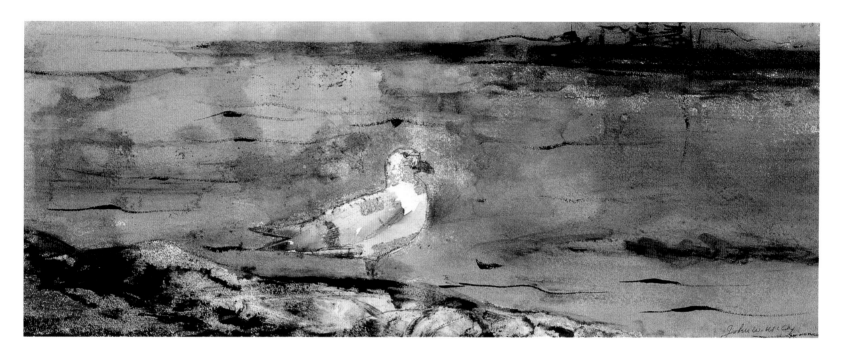

Anna B. McCoy

commentary by Christopher Crosman and Andrew Wyeth

Down East Books
Camden, Maine

JOHN W. McCOY, AMERICAN PAINTER
1910–1989

Farnsworth Art Museum, Rockland, Maine
June 17, 2001–October 14, 2001

Biggs Museum of American Art, Dover, Delaware
November 7, 2001–February 25, 2002

Copyright 2001 by Anna B. McCoy
ISBN 0-89272-527-3
Book Design by Lindy Gifford
Cover plate: Four Gulls, c. 1971, mixed media
Endpapers: Outcropping, c. 1960, mixed media
Title page: Lone Gull, c. 1963, mixed media
Printed in China
5 4 3 2 1

Down East Books/Camden, Maine

Library of Congress Card Number: 00-111297

Acknowledgments

My mother and I are grateful to so many people for helping to make this book a reality. It all started with my goddaughter, Renée duPont Harrison, who grew up with a John McCoy egg tempera called *Willow in Moonlight* (Plate 27), which hung in her mother's house. Inspired by this memory, she asked if she might begin work on a book that would explore my father's painting. We were all thrilled by the prospect and by the care and diligence with which she pursued this goal. Working with Renée's initial interviews and research, I was able to carry the project through to completion.

Most of the beautiful reproductions here are thanks to John Manning, with additions by William Thuss, the Santa Barbara Museum, the Brandywine River Museum, and the Pennsylvania Academy of the Fine Arts.

Margaret Fields was invaluable for her typing and retyping of the final drafts. And throughout the project my mother, Ann Wyeth McCoy, and my husband, Patrick Mundy, were excellent and supportive critics.

Chris Crosman, director of the Farnsworth Art Museum in Rockland, Maine, was a major source of support and advice. It was at his suggestion that we approached the publishing firm of Down East Books, where I found myself guided by the expert advice of Chris Cornell, my editor.

We could not have done this book had not the collectors and collections of my father's work given us permission to reproduce their paintings. I am deeply grateful to each one of them: the Brandywine River Museum, Mr. and Mrs. Richard S. Burroughs, Louise Philibosian Danelian, the Delaware Art Museum, Mr. and Mrs. Maurice P. di Marco, Renée duPont Harrison, the Farnsworth Art Museum, Margaret Fields, Christopher D. and Selden Dunbar Illick, Mr. and Mrs. Evans R. Jackson, Sherry Kerstetter, George Brinton Kipe, Ann Wyeth McCoy, Denys McCoy, Robin McCoy, the Pennsylvania Academy of the Fine Arts, Dr. and Mrs. Charles Lee Reese IV, Mrs. W. G. Reynolds, the Tower Hill School, the Millport Conservancy, Jean Wyeth Bell, Mr. and Mrs. Jamie Wyeth, and several other anonymous collectors.

I received invaluable advice from various people in the art world. I wish to thank Mary Landa, Victoria Manning, John Wilmerding, William Innes Homer, Richard Boyle, Pamela Belanger, and, of course, Elizabeth Hawkes, who wrote the introduction.

My uncle, Andrew Wyeth, who knew my father well, was most gracious to talk with Renée Harrison and to my sister, Robin McCoy, about my father and his work. His thoughtful commentary is presented in "Andrew Wyeth Talks About John McCoy."

Finally, all of us are eternally grateful to my father, who created an extraordinary body of work. It has been an honor and a wonderful experience to put together this book.

Anna B. McCoy
St. George, Maine and
Chadds Ford, Pennsylvania

Contents and List of Plates

Foreword

John McCoy represents a kind of "lost generation" of American realists who emerged in the years following World War II.

Aware of but independent from avant-garde styles, especially Abstract Expressionism, McCoy continued a longstanding tradition of American realism that has its roots in the writings of Emerson and Thoreau. It is a transcendent, spiritually evocative, and intensely personal response to the natural world and man's place therein. In a reversal of the nineteenth-century Academy versus avant-garde paradigm, Abstract Expressionism became a kind of new academy, and those artists who never fully embraced its style became quiet rebels beyond the accepted boundaries of "high art" and critical discourse.

The preeminence of Abstract Expressionism during the postwar years has been increasingly questioned by art historians and critics—acknowledgment that alongside Pollock, DeKooning, and Rothko, artists like Edward Hopper, Fairfield Porter, John Marin, Andrew Wyeth, and many others, including McCoy, were exploring the endlessly various modes of realism.

In important ways, McCoy was, in fact, very much of his time and the contemporary art scene. He strongly believed in the power of art to speak in universal terms about enduring aspects of the human condition and in its ability to communicate otherwise indescribable states beyond the mere representation of an object, person, or place. And through his teacher, N. C. Wyeth, who emphasized the empathetic union of artist and subject, McCoy arrived at an Abstract Expressionist esthetic wherein form, gesture, color, and composition are inseparable from content. Here, the means of expression is the meaning of the expression.

At the most basic level, a lightness of touch—and, in many of McCoy's watercolors, feathery brush strokes; soft, glowing colors; and expanses of whiteness—conveys the transitory qualities of a particular moment on a particular day. Although he was an admirer of Winslow Homer, McCoy and his watercolors are generally more attuned to the artists who immediately preceded him and who, in the 1950s, were all at the height of their powers: Hopper, Charles Burchfield, and Marin. In certain of McCoy's paintings, echoes of these artists, as well as his other heroes—Homer, Eakins, and even Cézanne—are seen in varying degrees and in various ways. However, in most of his work, sources and influences are subsumed in a highly personal style that is all his own. Like Andrew Wyeth, his younger painting partner and a fellow student of N. C., McCoy bridges abstraction on the one hand and representation, modernism, and tradition on the other.

For understandable reasons McCoy's work was often compared to Wyeth's. Yet, he was a very different painter with unique qualities, including an interest in the possibilities of mixed media, which pushed his work into new and distinctive terrain not ever seen before. McCoy was also, by all accounts, a deeply private man and artist. His works have a reticence and wonderful serenity, but beneath their placid surfaces there is emotional depth and precision. Subtlety and restraint do not lend themselves to widespread recognition, at least in an atmosphere that celebrates what critic Robert Hughes calls, "the shock of the new."

For the past half-century and longer, Maine has been particularly welcoming to artists who fall somewhat outside mainstream styles and movements. In particular, the state has appealed to those who are fully cognizant of the avant-garde but consciously choose to remain "a few steps behind," to use the memorable phrase that Alfred Barr once chose to describe what he believed to be the proper stance of the Museum of Modern Art.

Beginning in the 1940s, a long list of lesser-known but distinguished artists established strong ties to Maine, where abstraction and representation cohabit with extraordinary richness and variety. Among these are William Keinbusch, William Thon, Dorothy Eisner, Alan Gussow, Alice Kent Stoddard, Vincent Hartgen, Karl Schrag, Reuben Tam, Andrew Winter, James Fitzgerald, and Stephen Etnier. John McCoy was friendly with many of them.

Maine, of course, is attractive to any artist whose work takes form and meaning from Nature. But the spectacular beauty of the state also presents them with daunting challenges—to make it their own, to make it new, or to reveal some existing aspect of Nature that can be experienced in new ways. John McCoy met these challenges, challenges that at the time were far more interesting and important to him than critical acclaim and widespread recognition.

He and his generation were not so "lost" after all. They merely found their own way.

Christopher Crosman
Director, Farnsworth Art Museum
Rockland, Maine

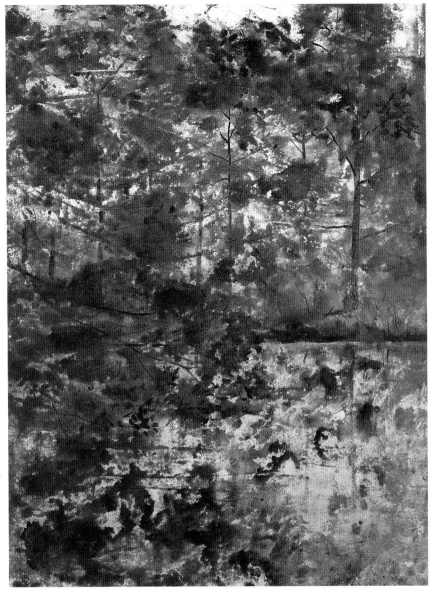

Wood Thrush, *c. 1970, 30 x 22 inches, mixed media on paper, Anna B. McCoy*

Introduction

John McCoy knew intimately the meadows of Chadds Ford and the shoreline of Maine. He was a keen observer of Nature—whether birds in flight, cloud patterns, or wildflowers in bloom. Lichens on a rock outcropping, a newly hatched gull, sunlight on snowdrifts, and treetops swirling in the wind were subjects he painted. Sun, wind, and mist were elements he observed and put to memory.

His wife, Ann Wyeth McCoy, remembers how "he loved the sound of wind through the trees and things moving." His paintings are not just about what he saw but what he heard. Sound—the cry of the gull in *Two Point Landing* (c. 1965, Plate 34), the insect buzz in *Wild Roses* (c. 1964, Plate 56), and the haunting song of the the bird at dusk in *Wood Thrush* (c. 1970, left)—emanates from McCoy's pictures. He captured the whole experience—what he saw, heard, and felt. The color of summer flowers, the sounds of insects and birds, and the sun's heat become one in his work. These are magical moments to savor.

In his early career McCoy mastered the techniques of oil, tempera, and watercolor. An admirer of Winslow Homer's late watercolors, McCoy became skilled in the medium himself, enjoying its spontaneity and fluidity. For many years he taught watercolor classes at the Pennsylvania Academy of the Fine Arts. One of McCoy's early works, *Caldwell Island Picnic* (c. 1936, Plate 6)—a get-together of the Wyeth clan in Maine—celebrates his fascination with quickly capturing the momentary aspects of a scene. At about the same time, he studied the technique of tempera painting, and as a result his watercolor style became more descriptive and less spontaneous.

In the late 1950s, McCoy began to experiment with new ways of applying paint, inspired in part by Abstract Expressionist Jackson Pollock's technique of dripping skeins of pigment onto a canvas. McCoy tried pouring paint onto paper placed on the floor, and he combined watercolor, oil, acrylic, and pastel in a single work.

In so doing, he developed a new painting process, which he dubbed, "McCoy's mixed media." First, he soaked a large sheet of paper, made partially of fiberglass, in water. Across that

wet sheet he poured oil paint, thinned with turpentine to the consistency of watercolor. Sometimes he tipped the paper, allowing the oil to flow across the surface and wiping away any excess with a sponge. Then, he applied watercolor, pastel, and acrylic to build up form and textures. Afterward, he laid the paintings outdoors to dry in the sun.

At first, these new works were merely experimental, but McCoy found the process exciting and cathartic. Though his subject remained the natural world, he was painting it in a new way. Still, remembering the advice of N. C. Wyeth, his teacher and father-in-law, McCoy selected subjects for which he felt empathy. He believed, "If you have a feeling about a thing, it will come down your arm and out of your hand," onto the paper or canvas. To paint surf, he became the wave itself, by letting the thin pigment float on the paper and by lifting the sheet to get the "feeling of the swerve" of the wave. He was now playing a more active role in the painting process itself.

Though quiet and reserved, McCoy was a person of strong character. His wife calls him "a real gentleman—he was a real gentleman in the Wyeth family, by gosh." When he wasn't painting, he enjoyed gardening and raised both vegetables and flowers. In Maine he maintained a large bed of delphinium, and he often painted the vivid blue blossoms against the sky.

An artist's vision is shaped, in part, by studying work of the past. McCoy was no exception. He admired Dürer, Constable, Homer, Eakins, and Cézanne. After studying art at Cornell University and in France, McCoy apprenticed for a year with N. C. Wyeth in Chadds Ford. In the studio McCoy worked alongside Andrew Wyeth, and a competitive spirit and kinship developed between them. Both young artists shared a keen appreciation for the Chadds Ford and Maine landscapes, and they enjoyed going on painting expeditions together.

McCoy credited N. C. Wyeth with stressing the importance of having empathy for a scene. McCoy's strength lies in evoking the mood of his subjects. In his early tempera *Four O'Clock Train*

(c. 1940, Plate 10), a train moves parallel to Brandywine Creek but does not intrude upon the placid stillness of the scene. By contrast, *The Wave* (c. 1964, Plate 35) shows the force of the wind on a stormy sea.

In his later years McCoy focused his attention on the Maine landscape and chiefly painted portraits in his Chadds Ford studio. He was saddened by the loss of farmland and by the housing developments that were changing the character of the Pennsylvania countryside he revered.

John McCoy was an introspective, poetic artist and a careful observer. What he loved in Nature was random chaos—the elemental, the spontaneous. And this is what McCoy captured in his art: the beauty, power, and transitory quality of the natural world.

Elizabeth H. Hawkes
West Chester, Pennsylvania

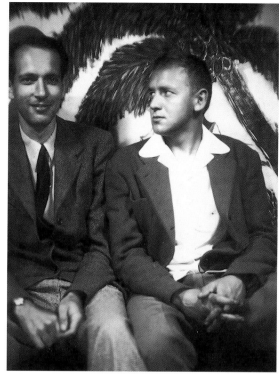

John McCoy (left) and Andrew Wyeth (right), c. 1941

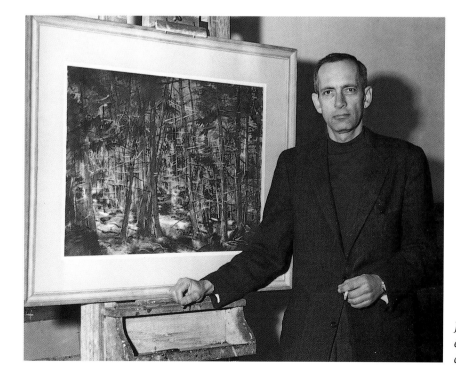

John McCoy with one of his early mixed-media paintings, c. 1955

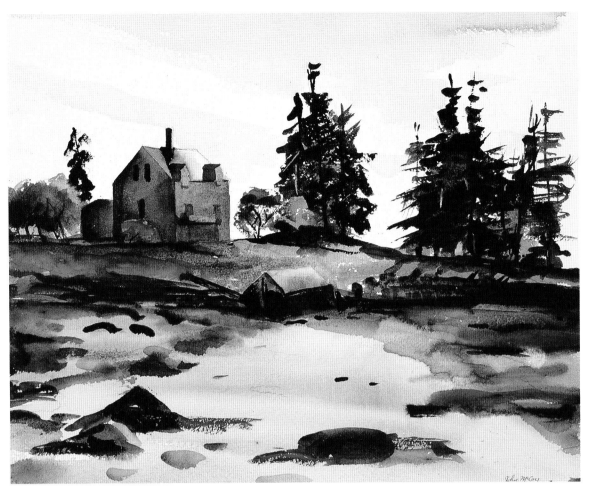

Figure 1. *Hupper's Island,* 1935, watercolor on paper, 20 x 24 inches, Anna B. McCoy

Andrew Wyeth Talks About John McCoy

Andrew Wyeth met John McCoy in 1933, when John was courting Andrew's sister, Ann. Subsequently, N. C. Wyeth brought John into his studio to study with young Andrew. What follows are comments recorded in a conversation with Robin McCoy and an interview conducted by Renée duPont Harrison.

I remember the first time I ever met John. We were coasting on a toboggan slide by the house, and he came out. He had black earmuffs on and was rather sedate looking. I was impressed by him. We got him on the toboggan and had a very nice time. I had an impression of this very nicely brought up, slightly removed, quiet, young man.

I soon got to know him better, and sometimes if there was a big snowstorm he would come out and stay overnight at the house. I always felt a great warmth in him. In the summer, John would come to Maine and stay there; and that's where he did a number of his early watercolors. [See Figure 1.] I remember that he bought a watercolor I had done; I think he paid me seventy-five dollars for it. And we began to paint together.

He had come out to my father's studio years before I knew him. His father, Jack McCoy, brought him. My father said, "Now this young man ought to start painting right away." But Jack said that he wanted John to get an education, at Cornell. My father said, "Then why did you waste my time by bringing him out here? Because if he's going to be an artist, it's a business. It's like any other field. This boy should start painting right away."

I'm saying this not to be detrimental to the McCoys, but to show what John had to fight against.

That, of course, is the problem most Americans have with art. They don't recognize that it is a business. It's just as if you were going into the medical field because you wanted to be a doctor: You would have to study for a long period. But, most people don't understand that.

This attitude is very prevalent. I'll never forget a very famous lawyer who worked down on Wall Street. He was from Martinsville, Maine, a town near Port Clyde, where we used to summer. He was a wonderful man who went right to the top and became very wealthy. Well, he had several

boys. I remember that he asked me to have lunch with him and his young son, who wanted to become a violinist. This was about thirty or forty years ago, just when I was beginning.

He said to his son, "Now, Mr. Wyeth is a painter, and he makes his living from making paintings. You must make up your mind that if you are going to be an artist you will have to live in small circumstances the way Mr. Wyeth does. You won't have cars or anything fancy. If you go into music, this is what it will be like." Well, the boy gave up music. Again, the only reason I bring this up is to demonstrate the kind of thing that John was up against.

When I was beginning to work in Pa's studio, he felt that I should have some competition, so he got John in there. He liked John, thought he was a wonderful, nice person. That's how it happened.

There must have been something that caught my father's eye. John had been trained in drawing and anatomy. He talked to me about Fontainebleau, where he was taught about forms of the human body and how to draw the deltoid muscles in order to get the round feeling. He loved architecture and stage design, which he studied before coming to work with my father. In the studio, when the model was resting, he and I would have long discussions about painting and drawing, and I learned a lot from him. I really did.

Pa would set things up. The portrait of Brinton Kipe [Plate 3] was one of the early things John did. I painted the same model, a profile of a young Mr. Kipe [Figure 2]. My father would criticize both of our works.

John was very dignified, a gentleman in the true sense of the word. For instance, take a look at the picture of John painting in a coat and tie [Figure 3]. If you saw me working, I would be sitting in the middle of a puddle with more paint on me than on the painting. I felt very warm toward John. I know that a lot of people felt that he was very sedate—which he was in a way—but underneath, John was rather wild. He was fun. He came from a family that I don't think really understood him. They were businesspeople. I don't think they really appreciated John's qualities, and I suspect he felt a little left out.

Yes, there was a real warmth in John. You know, when my father was killed, John took off months and spent them with me up in the studio going through things, fixing paintings for an oil show, and just being with me. I'll never forget it. He was terrific. I was smitten by it. It knocked me flat.

John was such a wonderful man, a warm man who was generous—*very* generous—with his time. I'm thinking about that warmth and the feeling John got from his wife and children that his painting was important. At times he was a little overcome by the vitality of his family, his children. I think John was a little shocked by what he created, but he loved being a family man. What he did was remarkable.

Anyone can see there is a relationship in our work. But, John finally branched out on his own. We both went in different directions, but we really appreciated what each other was doing. I think he got tired of the two of us working in the same style, but I really believe it was his natural development. You have to have something to begin with, then finally you find yourself.

I think he and I admired pretty much the same

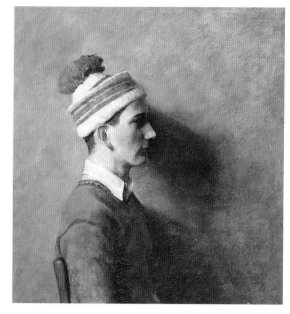

Figure 2. *Mr. Kipe*, by Andrew Wyeth, 1934, oil on canvas, 32 x 30 inches, Mr. and Mrs. Brinton Kipe

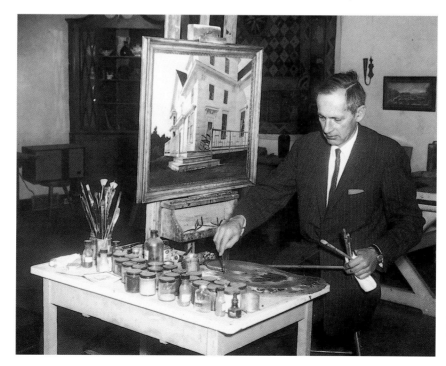

Figure 3. *John McCoy working on the painting* **Wawenock Hotel** *(Plate 14)*

people. He may have had a little more interest in the Impressionist painters. I was never terribly smitten by them. I would say that I became perhaps a little more of a realist than he did. I think John loved Winslow Homer's work, just as I did, and we discussed it a lot. We went to shows in New York together many times.

We would go off and do watercolors together, too. Sometimes we'd paint the same subject from different angles.

I remember when John did a portrait of me [Plate 7], and I did one of him [Figure 4].

During the war, John stopped painting and went to work at the DuPont Company. One day I saw a clipping of a piece that came out in *Newsweek*. It showed a reproduction of a watercolor that he did up in the Valley of Willows, and it said, "This man has a real sensitive feeling for landscaping." I took it over to him, and he turned away. He was very moved that his painting—which he hadn't been doing—really meant something.

I think in paintings such as the one of Tom Clark [Plate 20], John really found himself. I remember this painting well. It was one that I owned once and then gave to the Brandywine Museum. It has a wonderful feeling, an amazing quality. The characterization is so strong. I knew Tom well and painted

him many times, but I always felt that John did a much better job than I did. In fact, this man was a tall Negro with blue eyes. His family were slaves who had been shipwrecked. I've always felt that this painting was John as a Negro, a self-portrait. John was also a very tall man, with great dignity.

The watercolor *Bell Jar* [Figure 5] is particularly lovely. It's excellent, a real beauty. My brother Nat owns another one that I think is especially fine [Plate 51, *Evening Tide*]. And a lot of John's studies of flowers and shells are quite stunning [Plates 54, 55, and 56]. He had a quality, particularly in his watercolors. There was one he did called *20° Below* [Plate 11], looking out from a covered bridge, and it was a real beauty, very handsome. The Farnsworth Museum has a very fine picture of a pine tree at night, with a pair of headlights coming down the road [Plate 59, *Witch Corner*]. It has a real mood to it.

Illustration did not enter into John's work at all. Maybe the painting in the Metropolitan Life murals shows a little bit of his training. But John was not a dramatic illustrative painter at all. I think he enjoyed my father's illustrations, but I don't feel that was what excited him. In a way, I often wonder why he came to my father, because John was not a dramatist in the traditional sense.

I think John's best work shows him very completely. His paintings are modest and quiet, and they can very easily be overlooked. One thing I want to emphasize is what he contributed, in particular, to the history of American watercolor. It's very quiet. It could be years before John's fine contribution will finally be acknowledged. But if I ever did a book on the history of American watercolor, I would include John—not just because I knew him, but because I think he searched and found new qualities in it, things that were very much his own.

Eventually, John wanted to break from regular watercolor and our old style of painting. He got this new type of paper and would soak it in water. [See Figure 6.] In his Maine studio he had a regular bath that he would put the paper into, and he would also use oil mixed with watercolor. I think all of this excited John. He felt that he was finding himself, the real reason he wanted to paint. Sometimes it happens early in an artist's career, and sometimes it takes years. I think in Maine he felt more like himself, though I didn't see a great deal of him in his later years. He started spending more

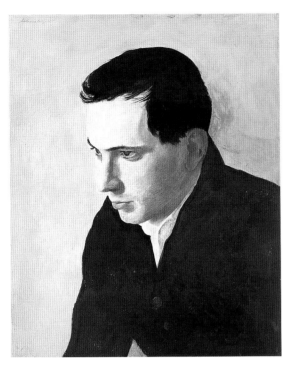

Figure 4. *John McCoy,* by Andrew Wyeth, c. 1938, tempera on panel, 20 x 18 inches, Ann Wyeth McCoy

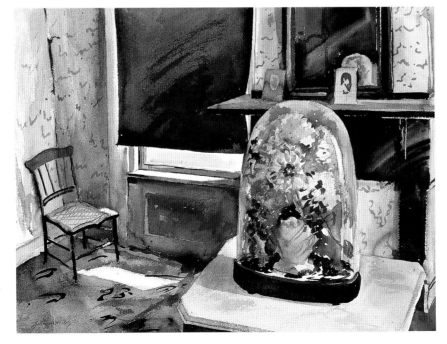

Figure 5. *Bell Jar,* c. 1950, watercolor on paper, 22 x 30 inches, Ann Wyeth McCoy

time in Wheeler's Bay, and I would drive over to see his work. But at that point, we had stopped painting together.

John's power was the withdrawn quality in his work. He was very sensitive, and he needed encouragement, which—as I mentioned before—I don't think he necessarily got from his parents. You know, a word of encouragement or excitement can do so much for an artist; it doesn't take a lot.

I think our family broke John open, and he began to enjoy life. He was used to having to sit down to dinner, with a butler serving and with his tie on. Our family was quite different. Pretty soon John began coming around with no tie on. Just natural. He began to relax. He would call my father "Pa" and my mother "Ma," and it was a very warm association. John was at ease with Pa; there was a very strong, lovely feeling between them. He would lie down on the sofa or on the rug in front of the fire, and not feel that someone was looking down on him.

He really had a very smoldering type of personality, and his excitement would come out in strange ways. Yet, John was not an overly excited person, which is why I enjoyed painting with him. He had a very calming presence. We had a good time together. I couldn't have done that with just anyone. We had a very warm relationship. John was something very, very special to me.

I really think he did some truly remarkable watercolors. Some of his temperas also had a real quality about them. In fact, in a way I was sorry to see him change into the new medium, though I think he got a more modern effect that he wanted. John did one tempera in London Grove, Pennsylvania, of a porch with the snow coming down [Plate 15]. It's lovely.

He might have been forcing his tones more in the mixed media. In my early work—with watercolor—I used a lot of brilliant blues and greens. John's work was always very low key, very toned down. I think I may well have been influenced by his rather somber look at things. There is a brooding quality, a smoldering power in his painting. That is what I loved about his work, and I think the best of his paintings have that quality.

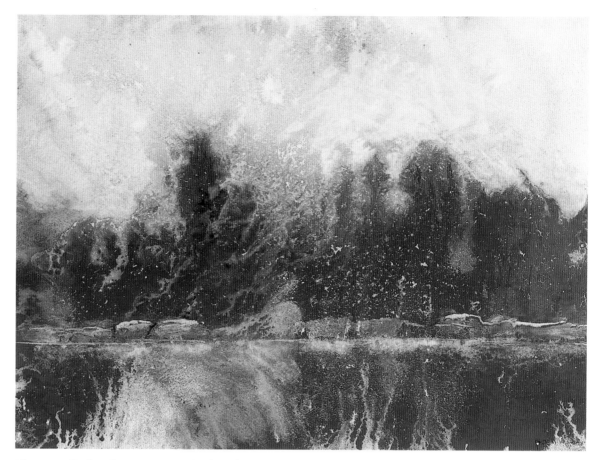

Figure 6. *Refractions,* c. 1972, mixed media on paper, 22 x 30 inches, Ann Wyeth McCoy

The Plates

This book chronicles John McCoy's life of painting and his struggle to find his own voice as an artist. In the end, the power of his work lies in the great emotional depth he was able to relate by reducing each painting to its essence, using his mixed media to obtain this force of feeling.

I hope the brief words that accompany these reproductions of my father's work will make you feel as though John McCoy's large hand has reached over and touched you for a moment.

—A.B.M.

I
―――
The Early Work

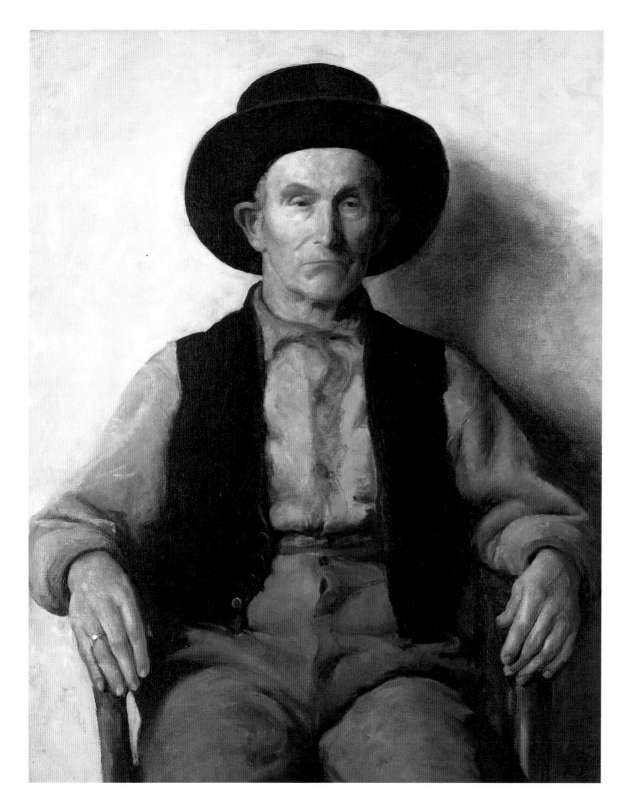

PLATE 1: Jimmy, c. 1934
Oil on canvas, 33 × 26⅝ inches
Anna B. McCoy

N. C. Wyeth brought John McCoy into the studio to give his son, Andrew Wyeth, some competition. N. C. set up still lifes and hired models for the two students to paint. This is one of McCoy's earliest portraits, of a man named Jimmy from the village of Chadds Ford, Pennsylvania. The sour expression was due to the model's harridan of a wife. Later she died of a gunshot wound—a suicide, according to the people in the village. No one would have blamed Jimmy for doing the deed himself. The hat, an often-used prop in N. C.'s studio, is pulled down so that Jimmy's ears stick out. Note his rough and meaty hands. All these features are portrayed with such sensitivity and compassion that one can feel Jimmy's utter resignation to his life.

Studio Still Life, c. 1934, oil on canvas, 24 × 30 inches, Anna B. McCoy

13

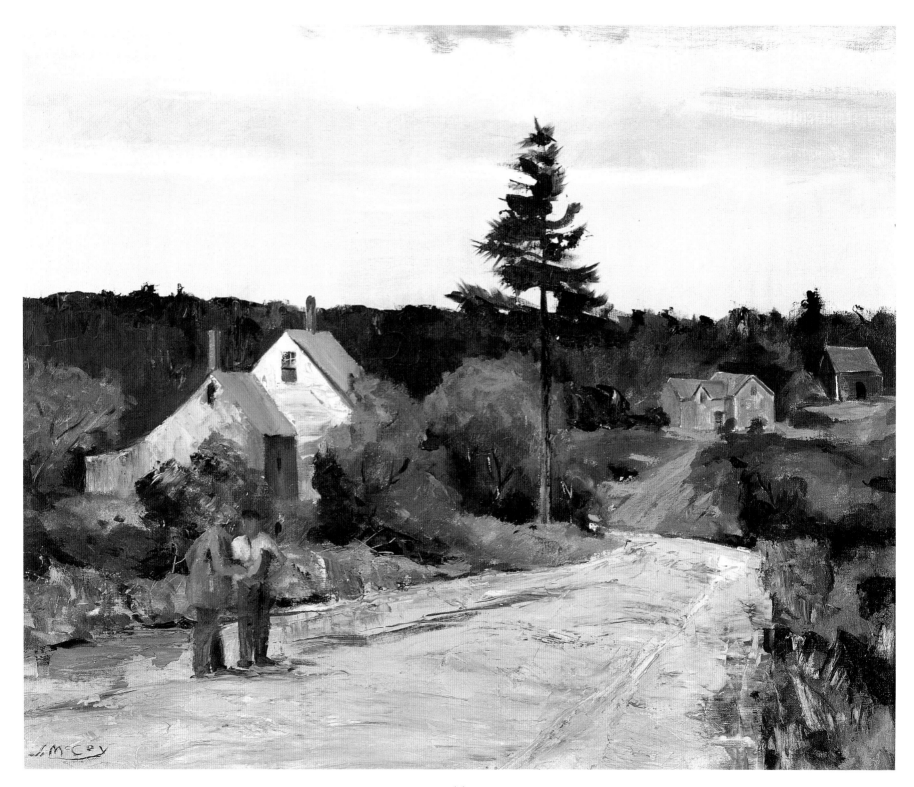

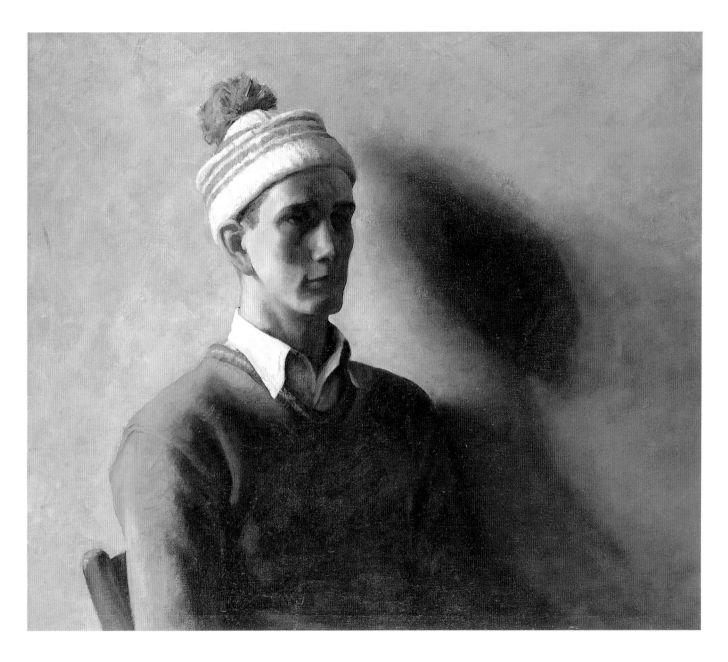

PLATE 2: Turkey Cove Road, c. 1935
Oil on canvas, 24¼ x 29¼ inches
Private Collection

An airy country road gives the feeling of a rural
village virtually untouched by industrial life. Here,
everybody knows one another. This very early oil
painting was done in Port Clyde, Maine, probably
when McCoy had just become engaged to Ann
Wyeth and was staying there with the Wyeth family.

PLATE 3: Brinton Kipe, 1935
Oil on canvas, 30 x 34½ inches
Millport Conservancy

This portrait was also painted in N. C. Wyeth's stu-
dio in Chadds Ford, this time of a young neighbor
named Brinton Kipe. Like Jimmy before him, the
sitter was given the hat as a prop. McCoy's years of
training at Cornell and in Europe show here in his
dramatic use of light and dark.

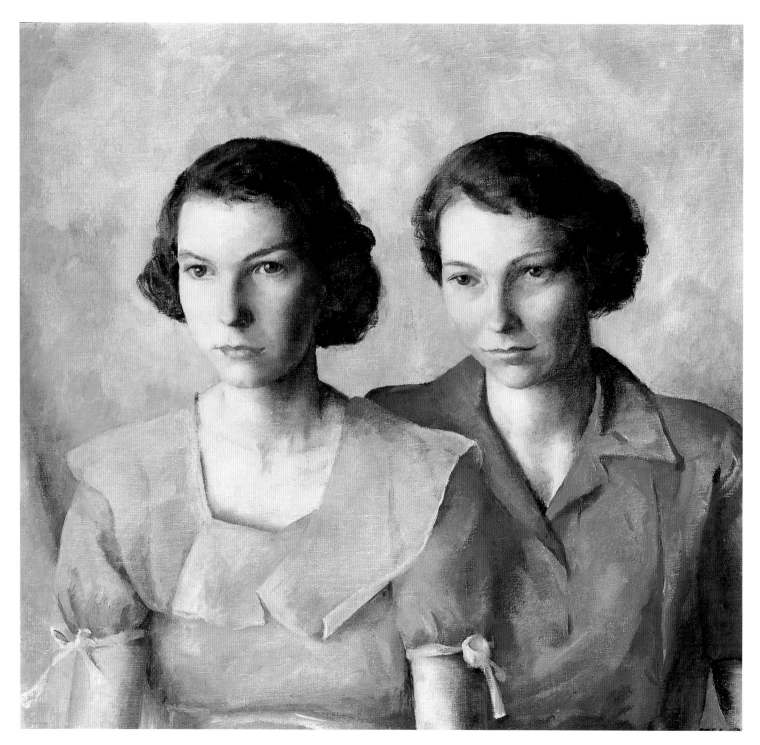

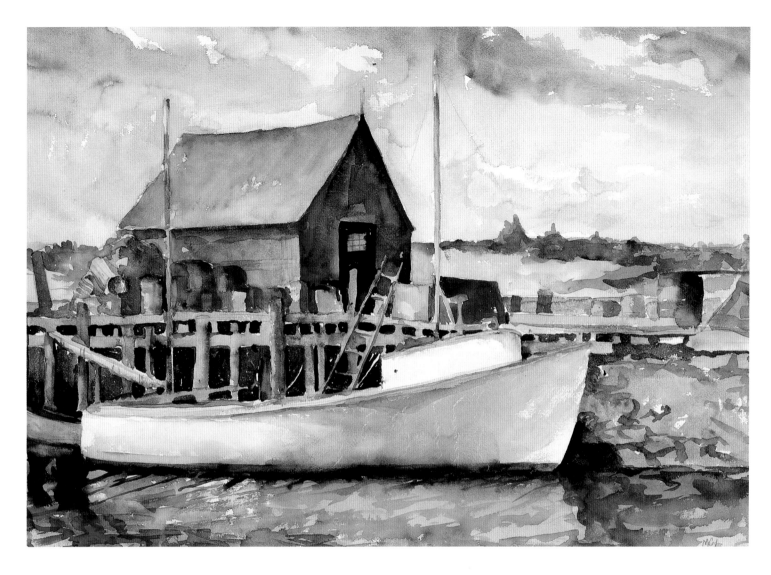

PLATE 4: Two Sisters, 1935
Oil on canvas, 29 × 31 inches
Private Collection

McCoy found this portrait to be quite a challenge.
He wrote to his fiancée, Ann Wyeth, in the summer
of 1935: "I am very much excited at the prospect of
painting a portrait of my two red-headed cousins
from Maine next week. They are ages thirteen and
fifteen—fiery red hair with assorted freckles—
straight as ramrods and shy as young deer." One
feels their innocence and youth reflecting the
artist's own qualities. At this time McCoy was try-
ing to decide between easel painting and set design.
Painting won, and so his career began.

PLATE 5: Lobster Boat, c. 1934
Watercolor on paper, 22 × 30 inches
Private Collection

Watercolor requires a quick and facile brush.
McCoy was so adept and in control of the
medium that in the end each painting has a
freedom suggesting it is easy to do—just as a
great dancer makes one feel capable of imitating
the difficult steps.

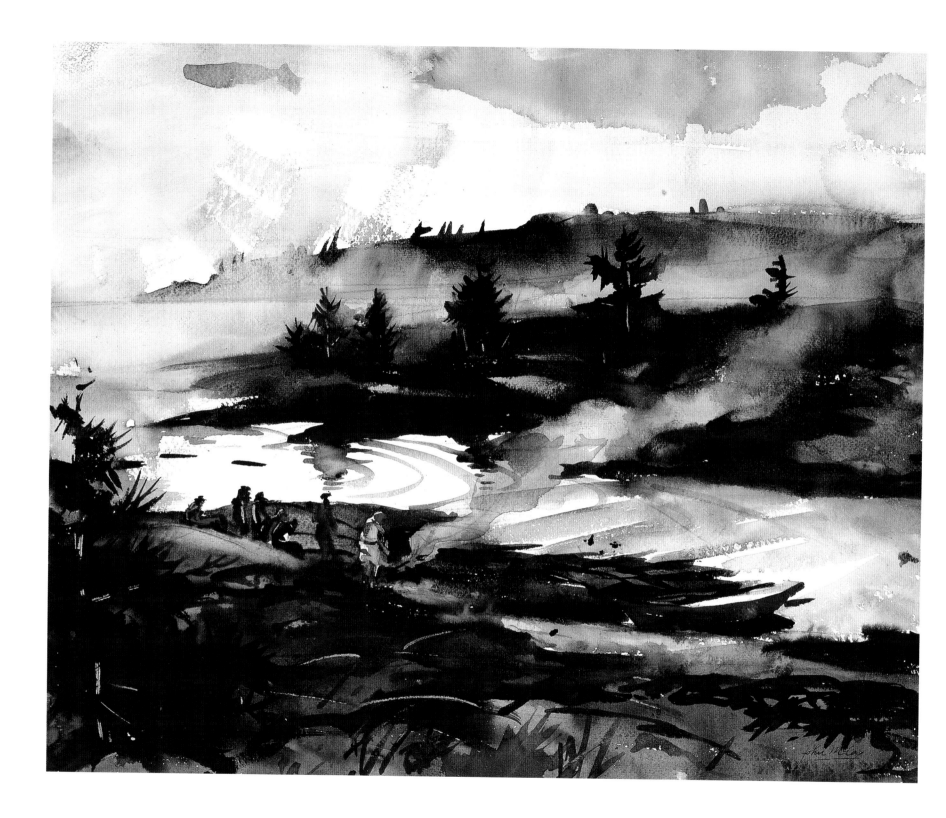

18

PLATE 6: Caldwell Island Picnic, c. 1936
Watercolor on paper, 18 × 24 inches
Anna B. McCoy

Done at a family picnic on Little Caldwell Island, this watercolor is, again, free and flowing. It shows promise of the work to come, when MCoy would use lots of water to create the atmospheres of which he was so aware: smoke, rain, and mist combined with the sounds of birds, wind, and sea. The painting records the artist's father-in-law and teacher, N. C. Wyeth, standing by the fire in his "plus-fours," with the rest of the family around him. These were joyous, happy days for John McCoy. In the heart of a family that not only worked hard but played hard, the atmosphere was informal and warm.

John McCoy with wife, Ann, c. 1936

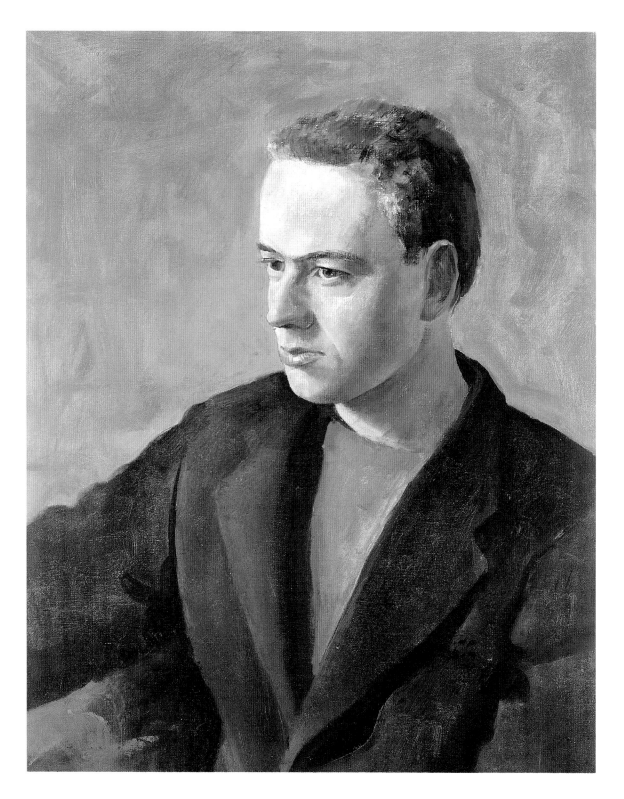

PLATE 7: Portrait of Andrew Wyeth as a Young Man, c. 1937

Oil on canvas, 25 × 20 inches
Ann Wyeth McCoy

This portrait was done at about the same time that Wyeth painted a tempera of McCoy (Figure 4, page 6). The two young men were close friends, fellow painters, and brothers-in-law. At this point, they were still painting together occasionally. Wyeth continued in watercolor and egg tempera, but McCoy kept experimenting with one medium after another until he eventually came up with his own. His oil of Andrew Wyeth is a wonderful, voluptuous play of many colors, revealing Wyeth's determination and introspection with sensitivity and power.

PLATE 8: Still Life with Hat Box, c. 1937

Oil on canvas, 34¼ × 40½ inches
Mr. and Mrs. Maurice P. di Marco

This oil is a playful insight into McCoy's mind at a period of pure joy and discovery for the artist. He felt full of daring and independence, as one can see by the props in this still life—executed, again, with a theatrical palette full of color.

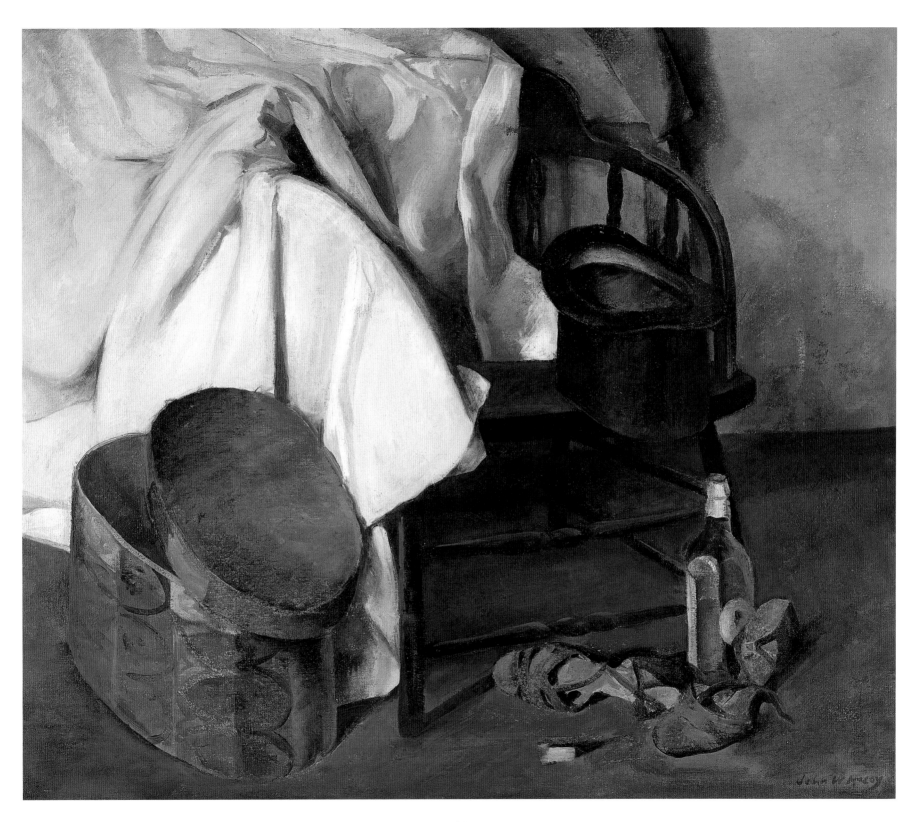

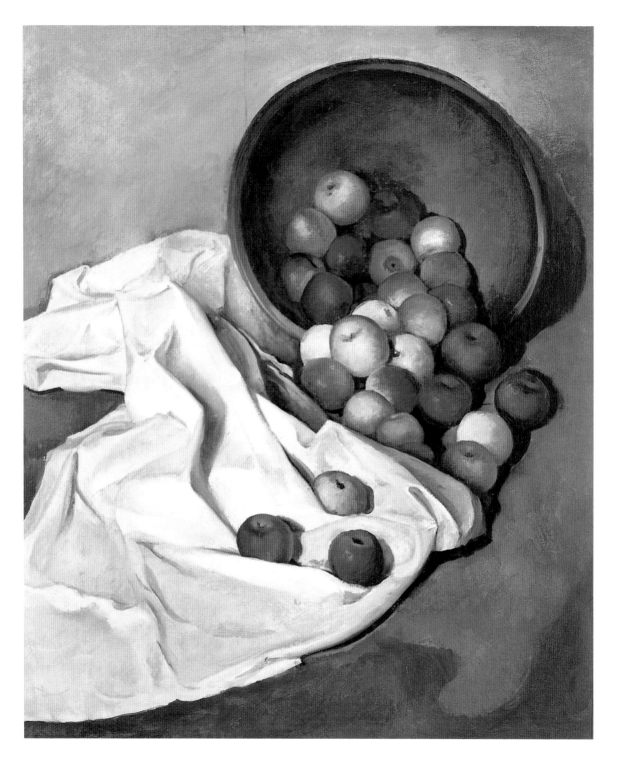

PLATE 9: Apples, c. 1938

Oil on canvas, 40 x 34 inches
Private Collection

This large still life of tumbling apples reflects John McCoy's need to stay in touch with his roots in N. C. Wyeth's teaching. It also demonstrates his continued love of the French painters—Cézanne, in particular. McCoy did many of these studio studies when he began to paint alone, primarily to keep his eye sharp and tools ready while he was searching for his own voice. Two major changes occurred at this time—one tragic, one joyous. First, his beloved mother, Anna Brelsford, died suddenly of an aneurysm. Soon afterward his son, John Denys McCoy, was born.

John and Ann McCoy with their infant son, John Denys, 1938

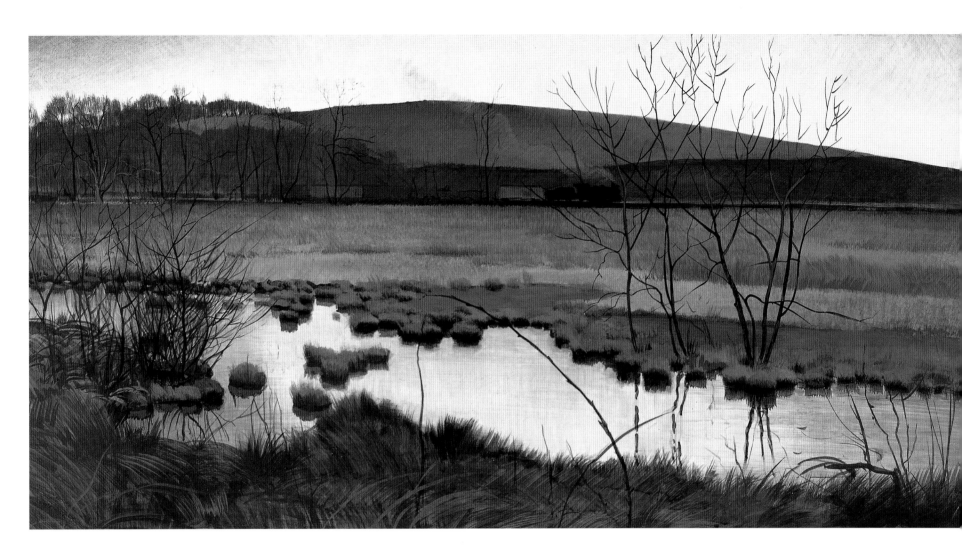

PLATE 10: Four O'Clock Train, c. 1940
Egg tempera on panel, 18½ x 35⅛ inches
Delaware Art Museum, Louisa duPont Copeland
Memorial Fund

This serious painting shows a train cutting
through a Pennsylvania landscape, destroying
its tranquillity. The artist's distress over these
invasions of the wildlife, hills, and valleys he
loved was hard to detect, but it was there—deeply
felt, subtly painted. McCoy's second child, Anna
Brelsford, named for his mother, was born the
year *Four O'Clock Train* was painted.

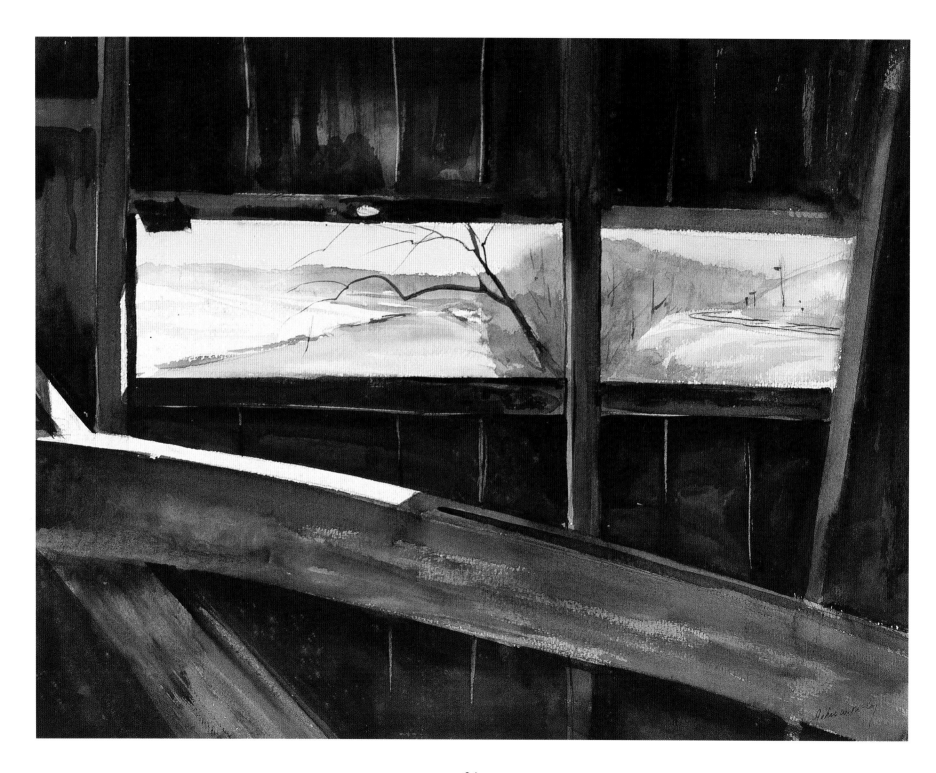

PLATE 11: 20° Below, c. 1942
Watercolor on paper, 26 x 32 inches
Mrs. W. G. Reynolds

Done in McCoy's loose and facile style, this watercolor shows the same railroad tracks as those in *Four O'Clock Train*. Only this time the artist depicts the scene from a more protected vantage point, from inside an old covered bridge.

PLATE 12: Out the Lane, 1944
Egg tempera on panel, 17½ x 23 inches
Ann Wyeth McCoy

In his first year of school, Denys McCoy walks out the lane to catch the bus early in the morning. This was another milestone in the artist's life, as was the birth of his second daughter, Maude Robin, that same year. With his family growing, McCoy was supplementing his income from various exhibitions of his paintings by working at the DuPont Company in Wilmington, Delaware. He hated it, but these were hard times. The war was depleting the country's resources. McCoy even sold eggs from his chickens in the lobby of the DuPont building. The family also had a Victory Garden and used a pony and cart for short excursions to the market in Chadds Ford.

PLATE 13: Wawenock—Bay Window, c. 1944
Watercolor on paper, 18 × 24 inches
Ann Wyeth McCoy

Finally, as the war drew to a close, John McCoy bundled his family off to Maine again. He rented an old hotel called the Wawenock in Port Clyde and spent the summer painting his surroundings and falling more and more under Maine's spell. It was a perfect place for him—isolated, with sudden shifts in weather and dramatic cloud formations. One of many watercolors of the hotel, this painting shows a lone window, eerie except for the warmth of the sun.

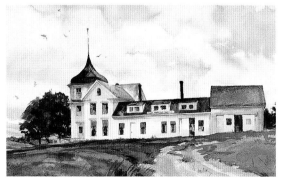

Wawenock Hotel, c. 1944, watercolor on paper, 20 × 28 inches, Ann Wyeth McCoy

Annex to Wawenock, c. 1944, watercolor on paper, 20 × 28 inches, Ann Wyeth McCoy

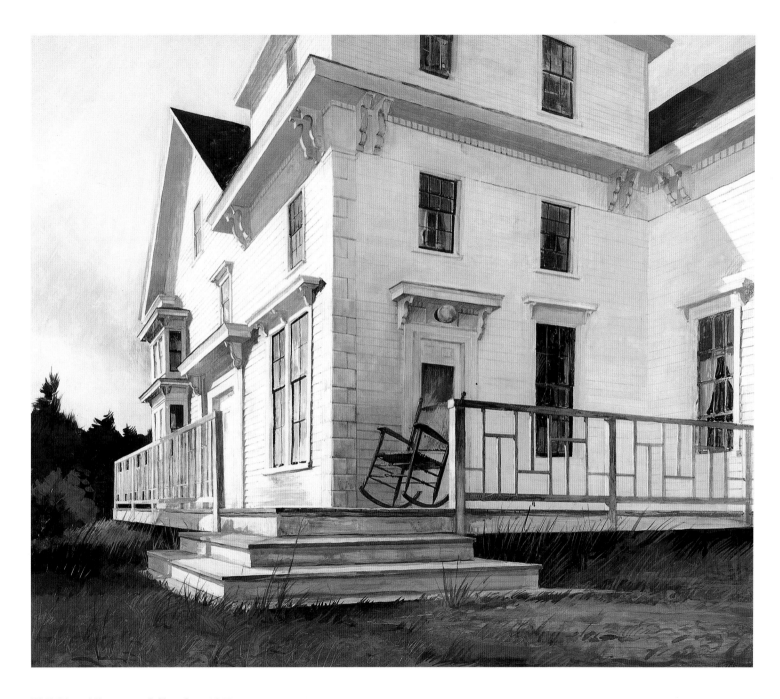

PLATE 14: Wawenock Hotel, c. 1944
Tempera on panel, 25 x 30 inches
Farnsworth Art Museum

In this egg tempera the isolation is complete, yet
there is nothing sinister about it. McCoy was just
beginning to recognize his own need to stand alone
as an artist, beyond the shadow of the Wyeth family.

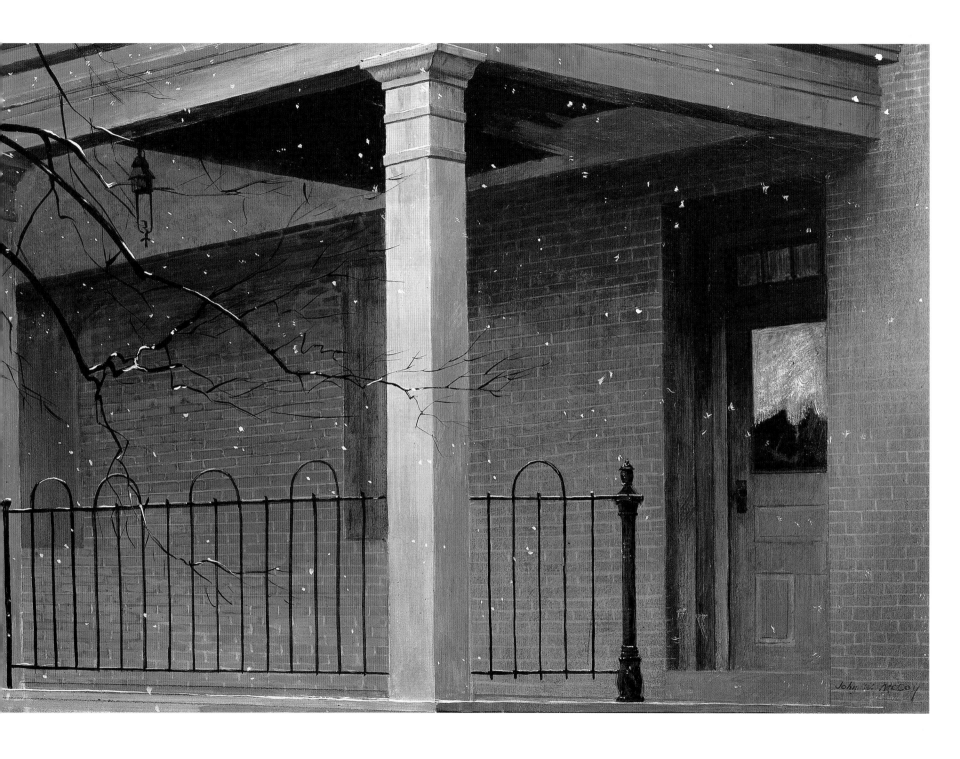

PLATE 15: Snow in London Grove
(The Corner), 1945

Egg tempera on panel, 14 × 20 inches
Santa Barbara Museum of Art, gift of Clement R. Hoopes

Tragedy struck the McCoy family again. Ann's father, N. C. Wyeth, was killed in a car at a railroad crossing in Chadds Ford. The elder Wyeth had been working on a series of murals for the Metropolitan Life building in New York City, and John McCoy and Andrew Wyeth were called in to finish them. McCoy must have felt as if he was back painting sets for the theater, as he had done during his days of study in Europe. Andrew gave up after working on one mural, so John finished the rest. He painted *Snow in London Grove* during the same period. There is a hint of McCoy's architectural studies in the angles of the porch, yet the structure is softened and made private and lonely again by the snow falling outside.

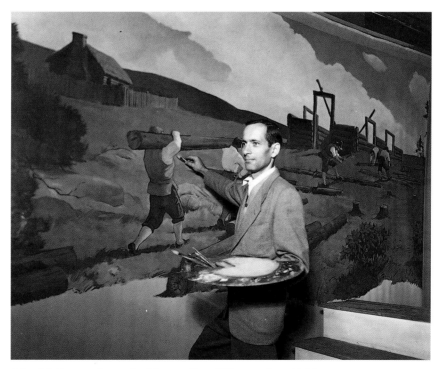

John McCoy works on the Metropolitan Life murals, c. 1946

29

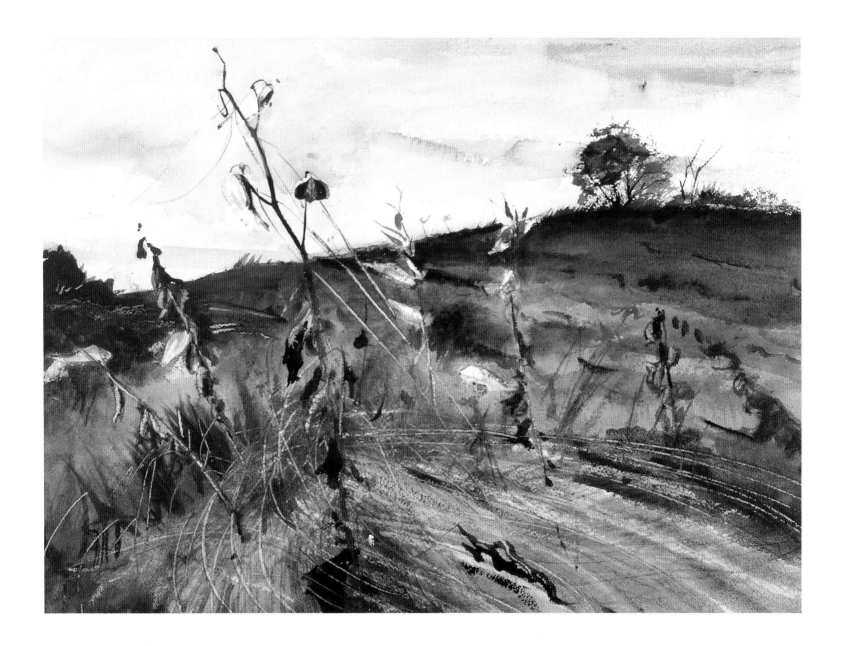

PLATE 16: Milkweed, 1947
Watercolor on paper, 22¼ × 30¼ inches
Delaware Art Museum, Louisa duPont Copeland
Memorial Fund

This watercolor is a free but agitated painting.
McCoy seems impatient to get on with it. His
palette has a darker hue than usual. The subject
suggests death and dying but offers no solutions—
only the fact that life moves along faster and faster
toward the inevitable.

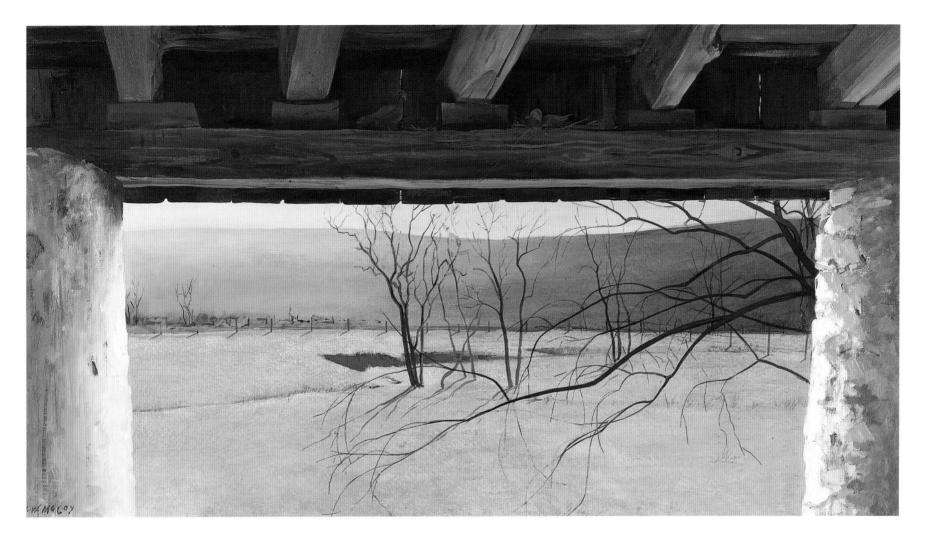

PLATE 17: Craige's Meadow, 1948

Oil and casein on masonite, 22³⁄₁₆ × 40³⁄₁₆ inches
The Pennsylvania Academy of the Fine Arts,
Philadelphia, John Lambert Fund

McCoy's own father shot his son's pet pigeons
when the artist was just a young boy. The lesson in
being tough was lost on John; instead he felt that
he needed to shelter and protect the vulnerable.
Here again are McCoy's pigeons, hidden safely
from the harsh world in the rafters of a barn.

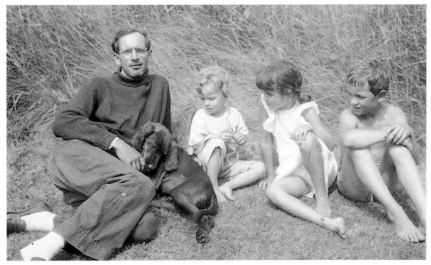

*John McCoy with Robin,
Anna B., Denys, and his
dog, Rocky, c.1948*

31

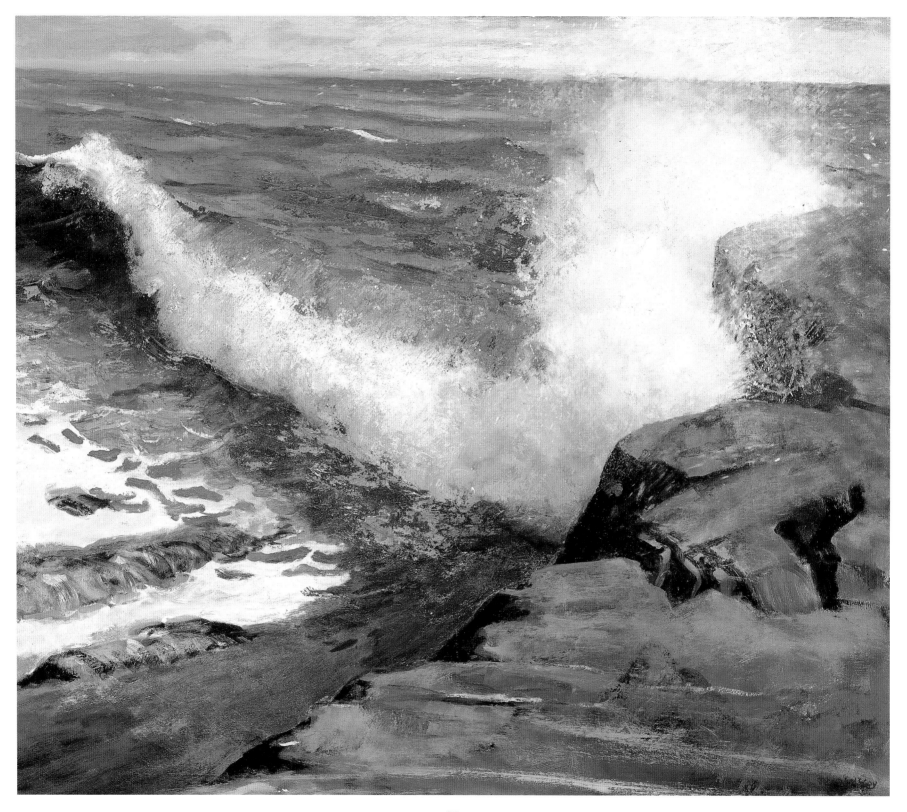

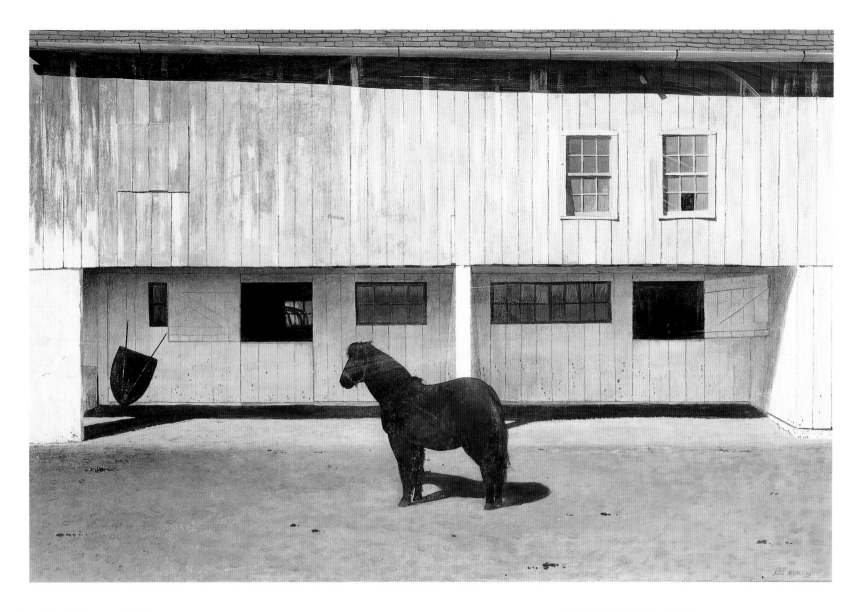

PLATE 18: Cannibal Shore, c. 1948
Oil on canvas, 36 × 40 inches
Anna B. McCoy

In Maine, McCoy painted every day during the summer, feeling the coast in all its beauty and fury. Here, in a large oil, he seems to express a sense of freedom, mixed with some frustration. In order to continue this kind of work, he needed to find his own house on the coast and did in 1949. It was about twelve miles down east of Port Clyde, in Spruce Head on Wheeler's Bay. This would prove to be McCoy's haven for the rest of his life.

PLATE 19: Midday, 1950
Egg tempera on panel, 24 × 26 inches
Private Collection

McCoy's work in Chadds Ford during the winter would start with pencil or watercolor studies and end in a tempera or oil finished in his studio. He was teaching watercolor at the Pennsylvania Academy of the Fine Arts in Philadelphia by now and loving it. *Midday* is a tranquil tempera of a barnyard full of sun and, according to one potential client, "the smell of manure." Again, the architectural element is important, but the atmosphere is enveloping.

PLATE 20: Green Pastures (Tom Clark), c. 1950

Egg tempera on panel, 17⅞ × 24 inches
Brandywine River Museum, gift of Mr. and Mrs.
Andrew Wyeth

McCoy felt, as the Native Americans did, that the
land could only be borrowed, not owned, and that
we should take care of it. Here, in *Green Pastures* he
has painted Tom Clark, a Chadds Ford man whose
ancestors included the very Native Americans who
inhabited the Brandywine valley two hundred
years before. His is like the background—dignified
and undisturbed by the encroaching world.

Hickory Hill Road, c. 1950, *watercolor on paper,*
14 × 22 inches, Anna B. McCoy

PLATE 21: Brandywine at Twin Bridges, 1953

Egg tempera on panel, $22\frac{7}{8}$ x 30 inches
Brandywine River Museum, gift of Alletta Laird
Downs in memory of W. Brooke and Marjorie H.
Stabler

Again McCoy records the peace and quiet of the
Brandywine River in Chadds Ford. The tree in the
foreground is hanging on to the riverbank for dear
life. Perhaps this is how the artist felt about the whole
valley—that it was just holding out against progress.
His handling of the medium, tempera, is brilliant in
its movement, a very difficult thing to achieve.

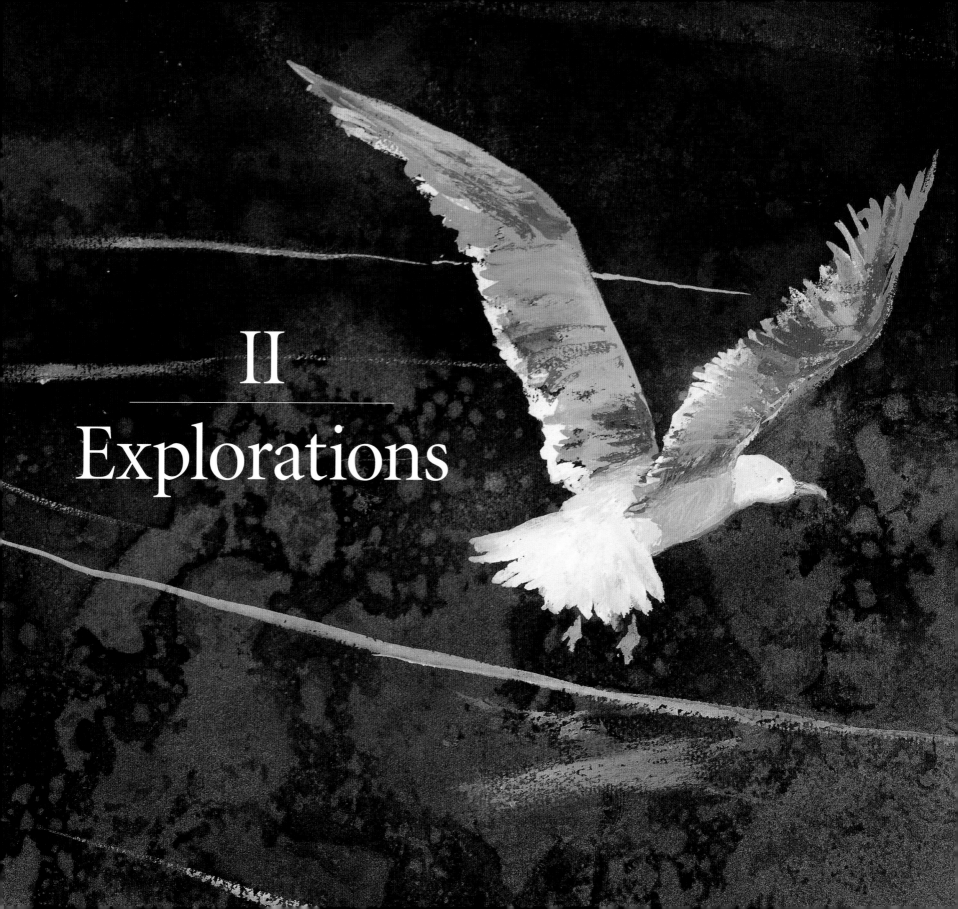

II

Explorations

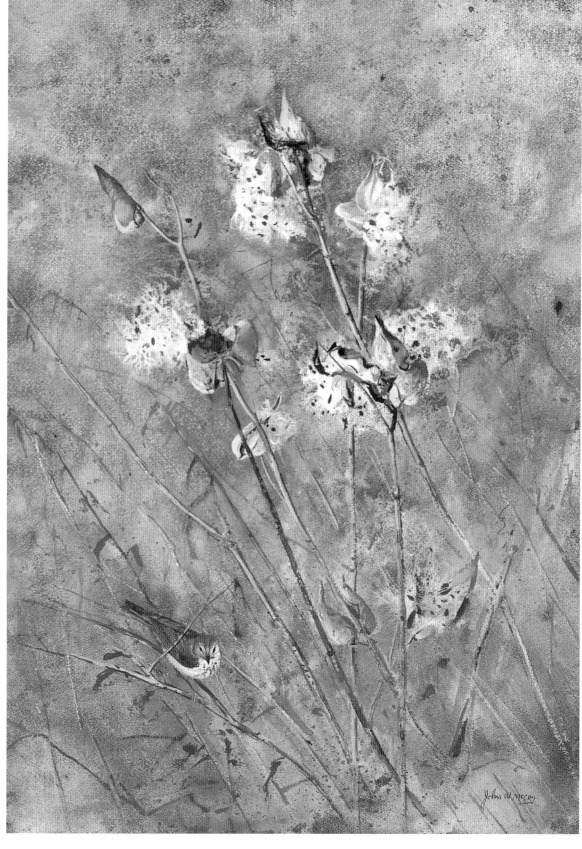

PLATE 22: Milkweed Seed, c. 1953
Mixed media on paper, 28 x 21½ inches
Private Collection

In this painting, John McCoy suddenly broke free. The traditional rules of watercolor, oil, tempera, acrylic, pastel, and pencil (or charcoal) went by the boards. As his new mixed media emerged, McCoy used all these materials whenever they suited him. With them he found that he could really make noise and feel the textures. This was the beginning.

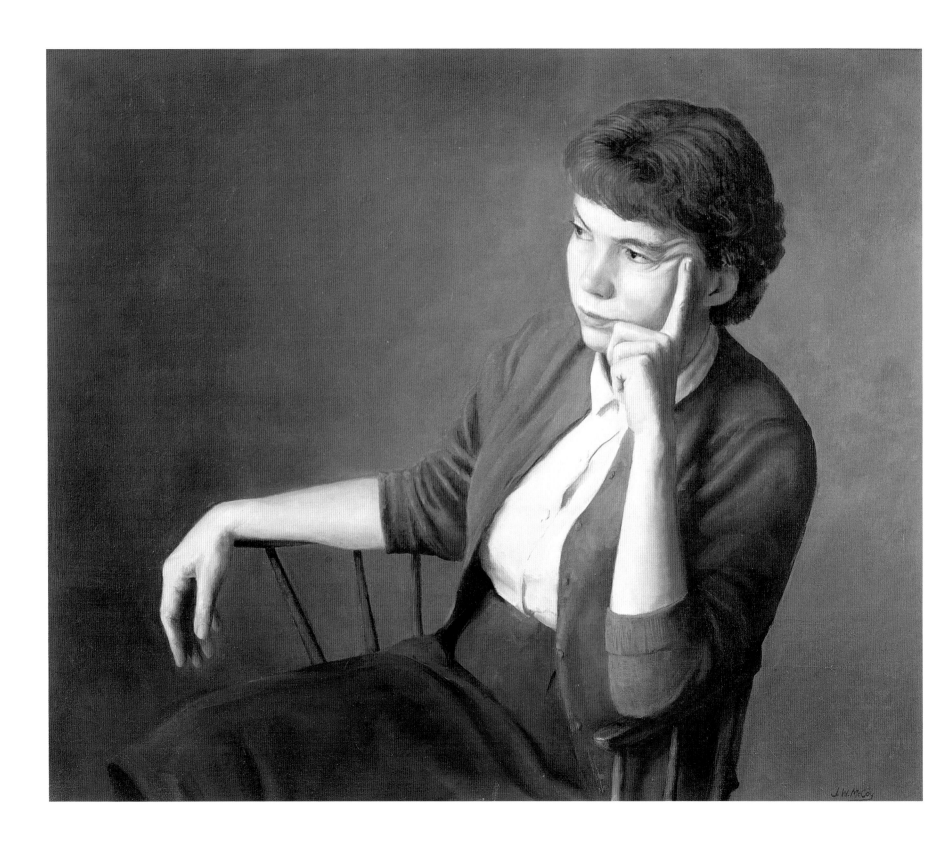

40

PLATE 23: Portrait of Ann Wyeth McCoy, c. 1955
Oil on canvas, 35 x 36 inches
Ann Wyeth McCoy

McCoy didn't abandon his oils entirely. Certain paintings—like portraits—required the academic style. He finally got his wife to sit for him. Ann was so busy with her music and children that it was rare for her to stop, but McCoy enticed her with new recordings of Beethoven, Chopin, and Rachmaninoff. Her revered teacher and beloved mentor, Harl MacDonald, died about this time, and the artist has captured Ann's reflective, sad mood.

John and Ann McCoy, 1954

PLATE 24: Henriette Wyeth Hurd, c. 1955
Pastel on paper, 19 x 14½ inches
Ann Wyeth McCoy

At about the same time McCoy painted his wife, he did a portrait in pastels of Henriette Wyeth Hurd, his sister-in-law. In this beautiful vignette, he has caught her acerbic wit and high intelligence, as well as the deep sadness in her face. Henriette had married Peter Hurd and moved to New Mexico, his birthplace, where she painted the people and the color peculiar to the Southwest. She loved it there, but she was terribly homesick for Pennsylvania and came back East often.

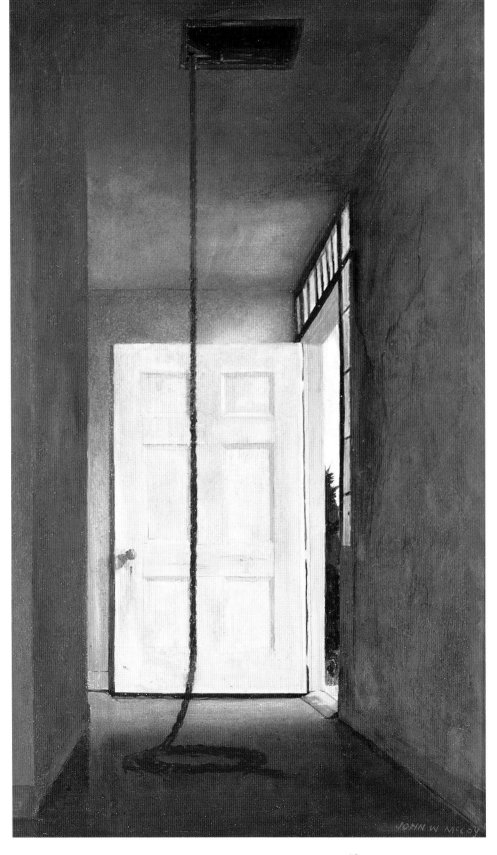

PLATE 25: Bell Rope, c. 1955
Egg tempera on panel, 23½ × 13 inches
Ann Wyeth McCoy

This tempera conveys an almost sinister quality. Hanging with incredible weight, the rope descends from a black hole. Thank God for the light from the outside—at the end of the tunnel, so to speak. John McCoy had a very spiritual side that could be both uplifting and darkly despairing. His light side was imaginative, hopeful, wise, and very perceptive. His dark side was reflected in his tales of torture, ghosts, and vampires. His children loved both.

PLATE 26: Seining Nets, c. 1955
Watercolor on paper, 22 × 30 inches
Denys McCoy

This watercolor of fishing nets hung out to dry is a tough test for the medium. It is very hard not to get "picky" with such a subject, yet—in swift strokes—John McCoy accomplished the ideal. Fresh as the day, this is the kind of watercolor about which one asks, "How long did it take?" The answer, of course, is twenty years.

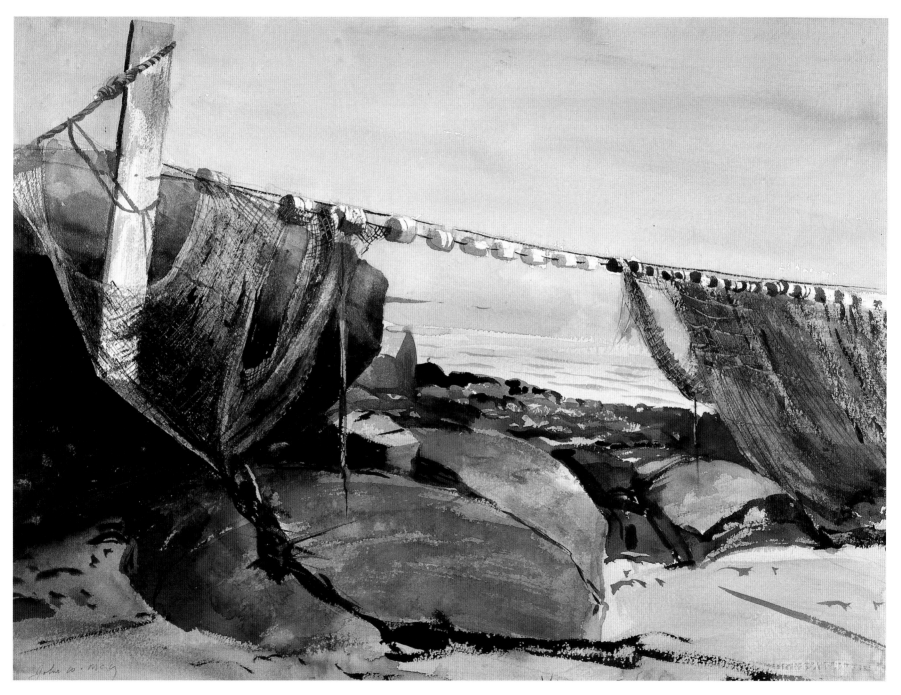

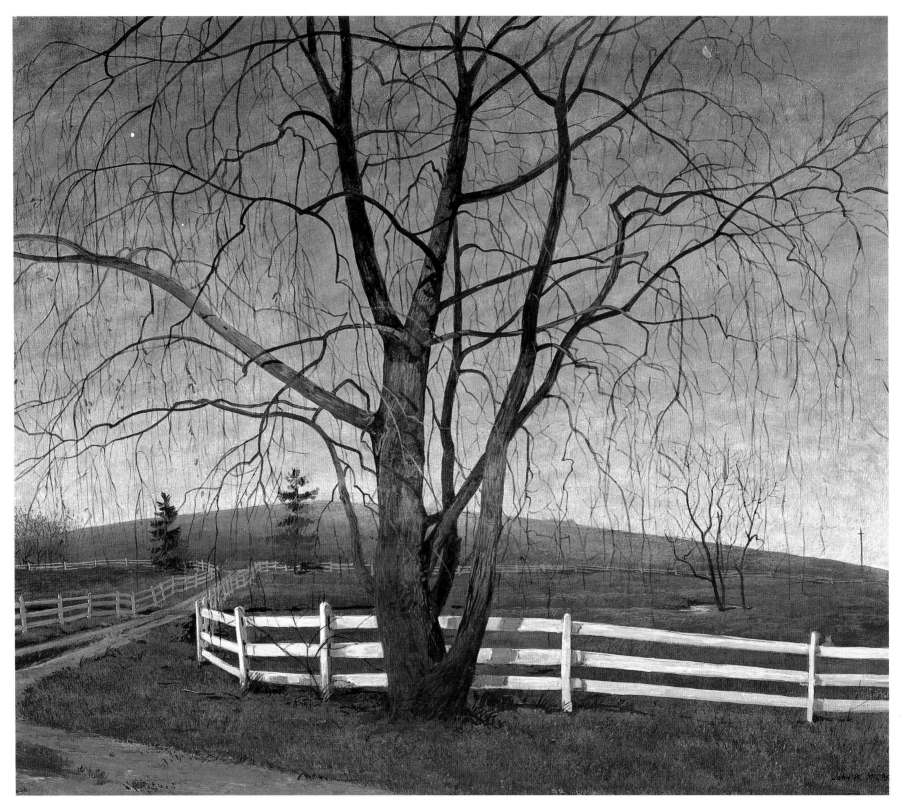

44

PLATE 27: Willow in Moonlight, c. 1955

Egg tempera on panel, 25 × 30 inches
Louise Philibosian Danelian

Willow in Moonlight, a tempera, is an amazing feat in this medium because of its darks and lights. Here again are John McCoy's beloved Pennsylvania hills in the absolute stillness of the night. How he loved the skies, with their stars and clouds.

PLATE 28: Young Gull, c. 1958

Mixed media on paper, 29½ × 21¼ inches
Dr. and Mrs. Charles Lee Reese IV

This is the first mixed-media painting that Anna B. McCoy remembers vividly. "I was seventeen," she recalls, "and one evening, when my date and I returned from dinner, we sat in our living room, where *Young Gull* was hanging over the piano. A lively argument ensued. I said the painting was the beginning of life. My friend was adamant: he insisted it meant death and hated it. We were both probably right. It recalls my father's childhood and the death—by his father's hand—of his pet pigeons. This was a terrible tragedy for the boy, and he never forgot it. He hated hunting and shooting of all kinds. He couldn't even bear to eliminate the many pigeons that inhabited the barn where his studio was, though they made an awful mess."

Here, in *Young Gull*, is McCoy's version of "pouring paint on paper," as Jackson Pollock did it. But McCoy mastered the technique in his own way. The effect is a moving, bursting flow of liquid and a moment in time.

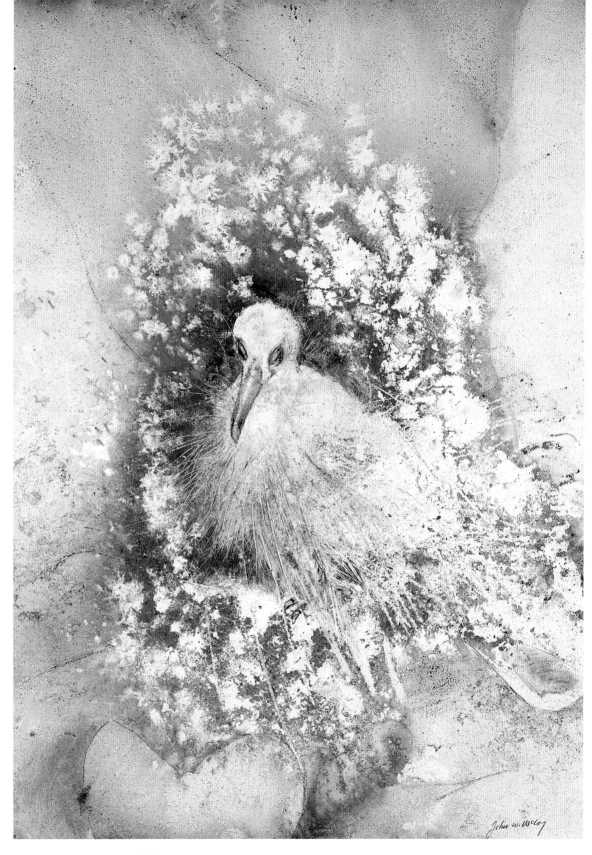

45

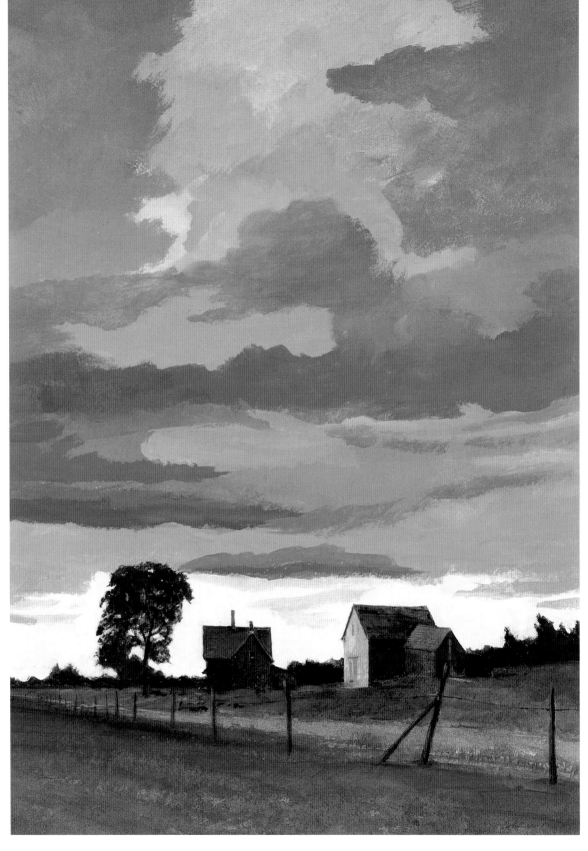

PLATE 29: Victor's Place, c. 1959
Mixed media on paper, 30 x 22 inches
Robin McCoy

A very powerful image was conceived in *Victor's Place.* Using his new medium McCoy created glowering skies with acrylics, oil, and watercolors. The clarity is astounding considering how easily one can make "mud" with this combination. The subject, a wonderful back-country place, was full of the smells and sounds of a working farm. McCoy returned here often, painting the surrounding fields, trees, and wildflowers.

46

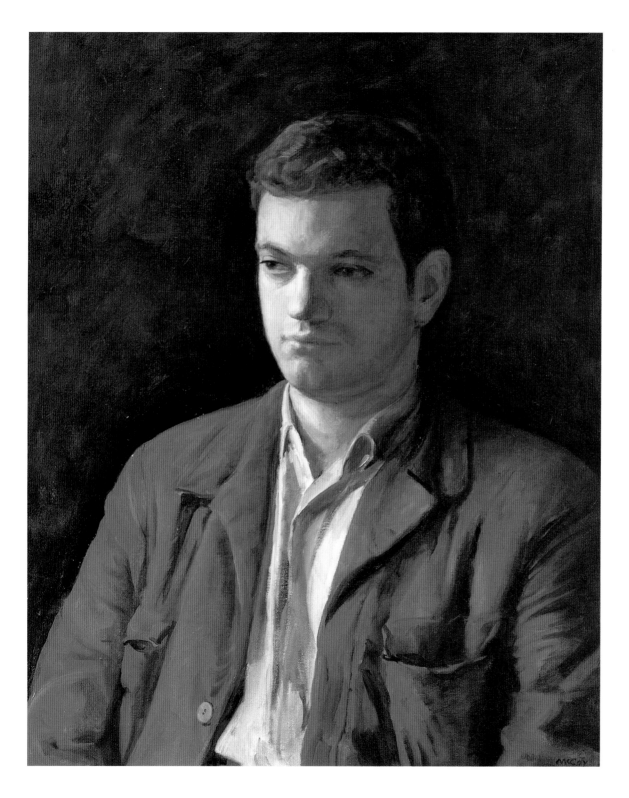

PLATE 30: Portrait of Denys, c. 1959

Oil on canvas, 25 x 19½ inches
Denys McCoy

This is a father's portrait of his son. Look at the disgruntled expression on Denys's face. Anna B. McCoy remembers her father coming in from the studio, wanting the boy to pose. Denys had either overslept—it was the weekend, after all—or he had run off to play football or cards with his friends. But McCoy persevered and caught a very young man coming to terms with growing up and not liking the responsibility of it all.

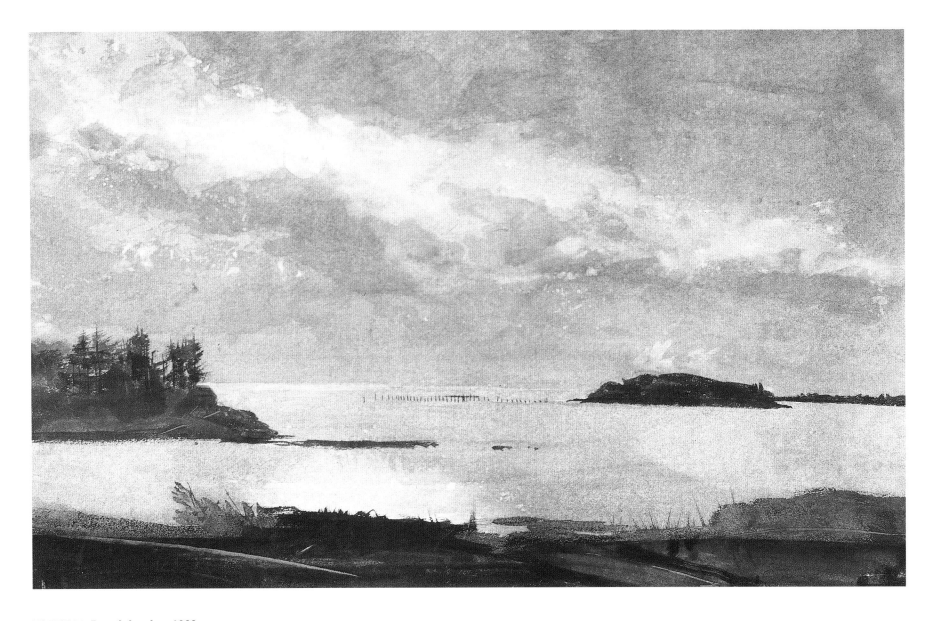

PLATE 31: Ram Island, c. 1960
Mixed media on paper, 22 × 30 inches
Mrs. W. G. Reynolds

This was the view from the McCoy summer
residence on Wheeler's Bay in Maine. Always
changing in light, mood, color, and season, it
never ceased to fascinate the artist, who painted
it many times. Here the mood is calm before or
after a storm. McCoy loved cloud formations,
and his new medium was the perfect vehicle for
his expressions and impressions.

48

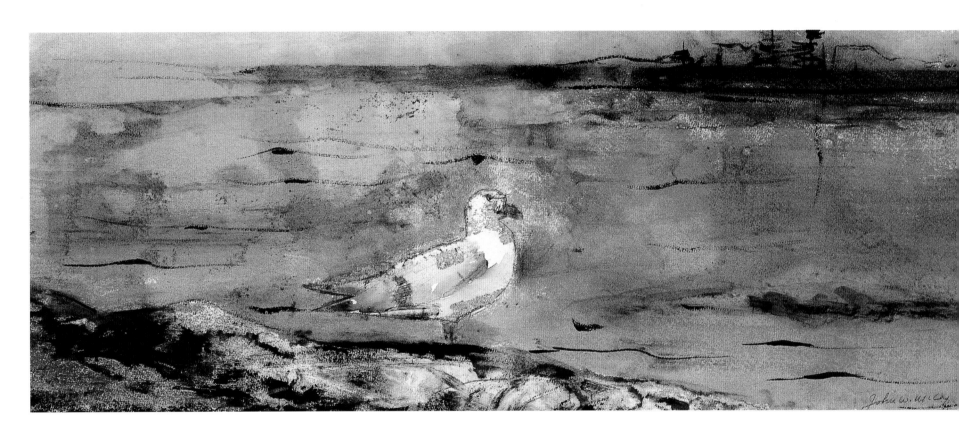

PLATE 32: Lone Gull, c. 1963
Mixed media on paper, 15 x 30 inches
Ann Wyeth McCoy

Gulls were a constant subject for John McCoy.
They represented such freedom to him, and he
found them tough and self-sufficient. There was
no need for humans in their lives as they plied
their scavenger ways. This depiction in the new
medium is scratchy and almost coarse, its texture
sounding like the screech or laugh of a gull.

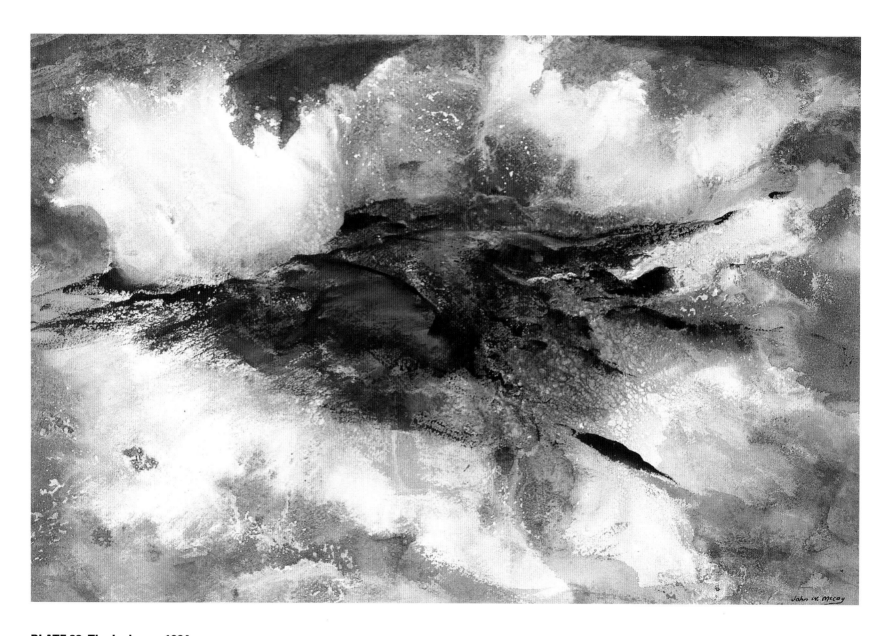

PLATE 33: The Ledge, c. 1964
Mixed media on paper, 22 × 30 inches
Private Collection

In *The Ledge*, McCoy's use of his new medium was
in full swing. Water and surf, rocks and seaweed
are all wonderfully moving, crashing, splashing,
and foaming. His dropping the paper in a vat of
water, then playing with oils and sponges and
acrylics came together with great doses of passion
and exuberance to make the surf explode out of
the painting.

PLATE 34: Two Point Landing, c. 1965
Mixed media on paper, 22 × 30 inches
Robin McCoy

How often we see birds of the ocean come in for a
landing. Here McCoy provides a bird's-eye view of
the rapidly approaching water. The artist has layered
his paint, sponged off the paper, and layered again
to create the depth of the sea and the reflections of
the sky.

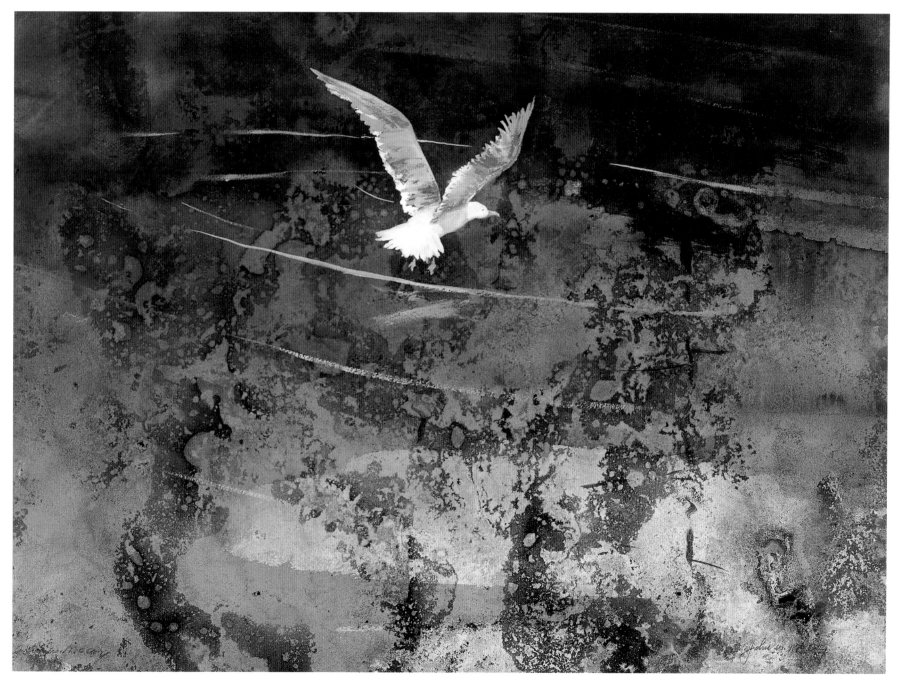

51

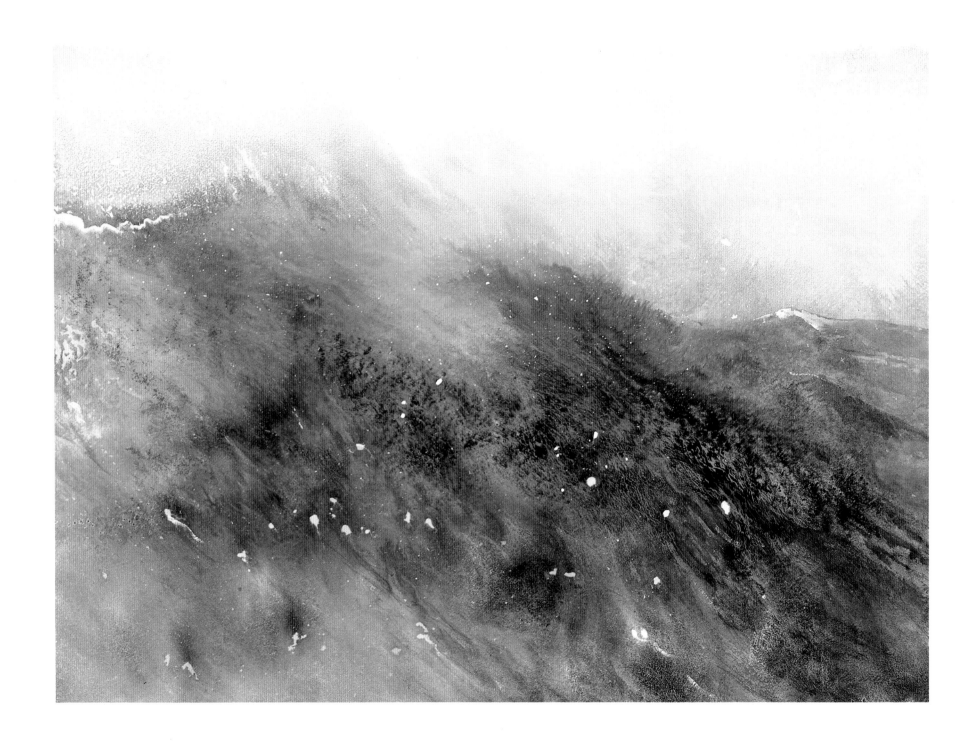

PLATE 35: The Wave, c. 1964

Mixed media on paper, 22 × 30 inches
Private Collection

The swell of the ocean in the middle of the
Atlantic is downright terrifying. John and
Ann McCoy were returning from abroad by
ocean liner in November 1960 when they
were caught in a terrific storm. At one point,
Ann was thrown across their cabin, cutting
her head open. Hand ropes were put up in all
the corridors and salons, and the ship was
three days late coming into port. John McCoy
captured the feeling of this experience in one
huge wave.

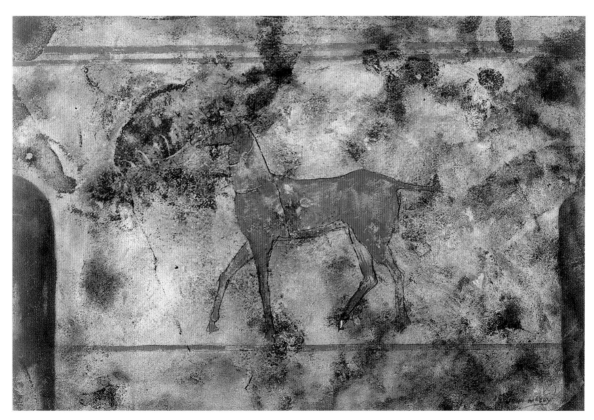

*Etruscan Horse (another memory of the trip abroad),
c. 1965, mixed media on paper, Anna B. McCoy*

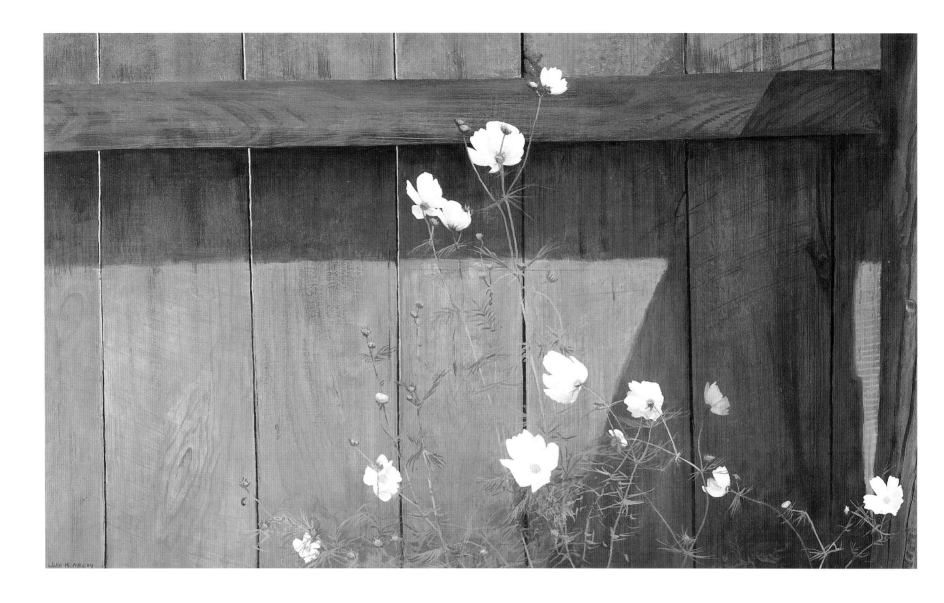

PLATE 36: Dooryard, White Cosmos, c. 1965
Egg tempera on panel, 24 × 44⅞ inches
Brandywine River Museum, gift of Amanda K. Berls

Flowers were important to McCoy, and he loved painting them. This is a rare tempera of flowers; he usually chose straight watercolor, because of its quickness and fluidity, or the new mixed media, which put so many tools at his fingertips. The delicacy of the cosmos may have inspired his use of the transparent tempera. McCoy caught the fragility of the flowers in the brilliant, clear sunlight of a typical Maine day. They appear bleached, like the fence.

PLATE 37: Wheeler's Bay (Forrest A. Wall), 1965
Oil on canvas, 25 × 30⅛ inches
Farnsworth Art Museum, gift of the artist, 1967

Every once in a while McCoy would return to his oils for a portrait. Here he has painted his oldest Maine friend, Forrest Wall. Forrie, as the family called him, was a warm and extremely intelligent Tenants Harbor man who met a need in the artist that had been unfulfilled since he was a small boy.

As much as McCoy loved his own father, who died in 1961, he could never talk openly and frankly with him. With Forrie, that kind of conversation was possible. The relationship was one of mutual admiration and respect. Forrie was brimming with robust chatter and singing, McCoy awkwardly but happily joining in the rhythm. The portrait makes clear that the artist deeply appreciated Forrie's dignity and intellectual capacity.

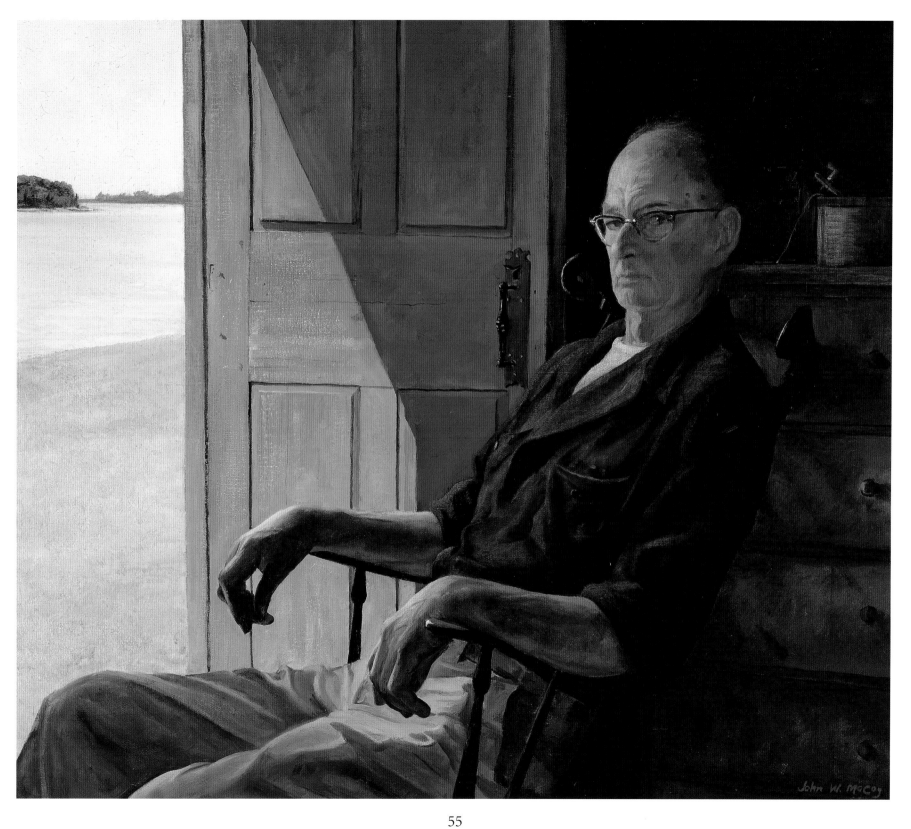

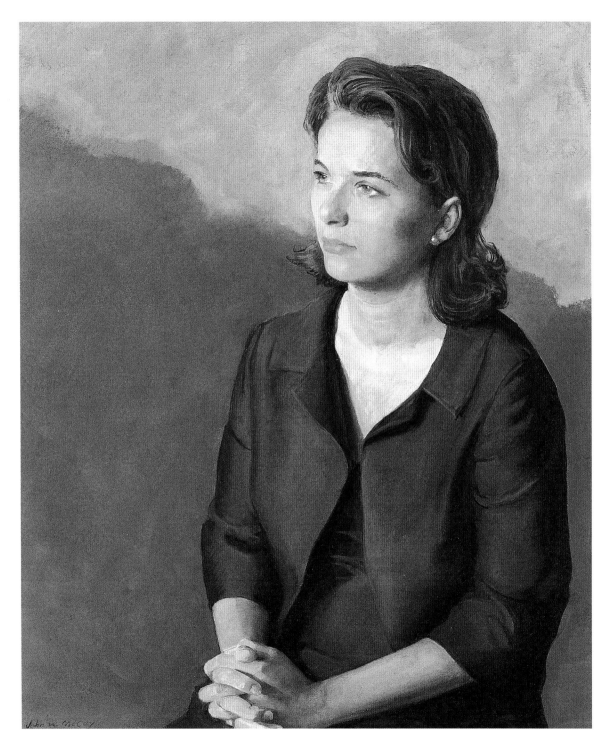

PLATE 38: Portrait of Robin, c.1962
Oil on canvas, 30 × 24 inches
Robin McCoy

This portrait of McCoy's younger daughter was painted at a time when she was about to enter the real world. Her grown-up clothes and hair belie the apprehensive tension in her body and her clasped hands. The painting clearly shows the artist's early academic training abroad and in N. C. Wyeth's studio.

PLATE 39: Portrait of Anna B., c. 1965
Oil on canvas, 30 × 40 inches
Anna B. McCoy

McCoy did this portrait as a Christmas present for his older daughter's husband. She recalls, "I would sneak over to his studio to pose, which was a long and painful process for me at the time. He played his records of Bach, Beethoven, and Rachmaninoff. It was all very overwhelming—the posing, the music, the marriage—and he captured my withdrawal into a safer place."

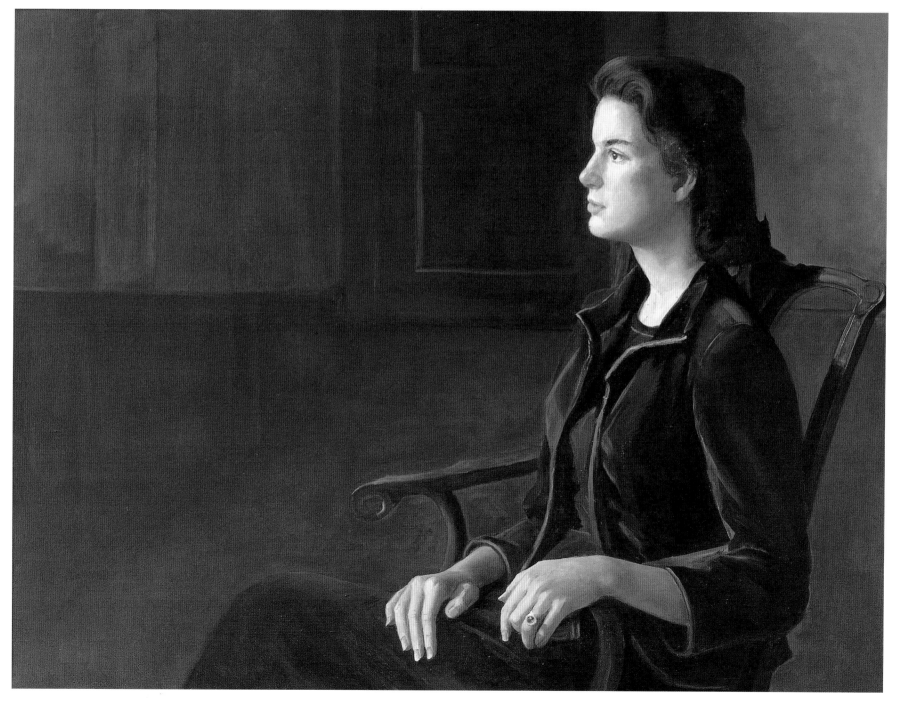

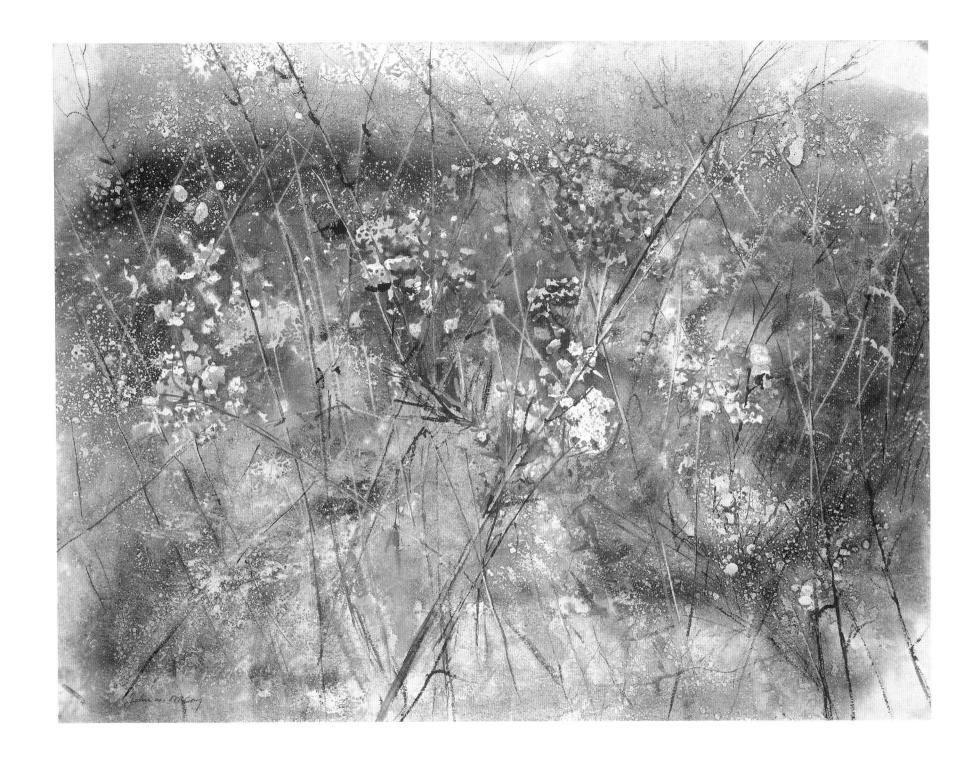

PLATE 40: Winter Weeds, c. 1965

Mixed media on paper, 22 × 30 inches
Brandywine River Museum, gift of Mrs. Ferdinand
LaMotte III in memory of Phyllis duPont Schutt

Like the painting *Young Gull*, this could be the
beginning or the end of life, the wonderful browns
of winter surrounding the bursting seeds of the
milkweed pods. McCoy loved walking the hills of
Pennsylvania, and one can almost feel the dry
crackle of the weeds and the stickiness of the
burrs. His straightforward control of the mixed
media is remarkable in the face of the chaotic nat-
ural world he is revealing.

PLATE 41: Sea Mist, c. 1967

Mixed media on paper, 30 × 22 inches
Private Collection

Trees were another of John McCoy's favorite
things, and he painted them in all kinds of light
and weather. He appreciated them for leading
one's attention to the skies he also loved to paint
and for the shapes they would become as they
reached for the sun. Once, when telling his daugh-
ter Anna B. how to paint a tree, he imitated one
using his big, awkward hands and arms as the
branches. He became the tree. As a tree, he would
appreciate the delicious atmospheres around
him—like the enveloping mist from the sea.

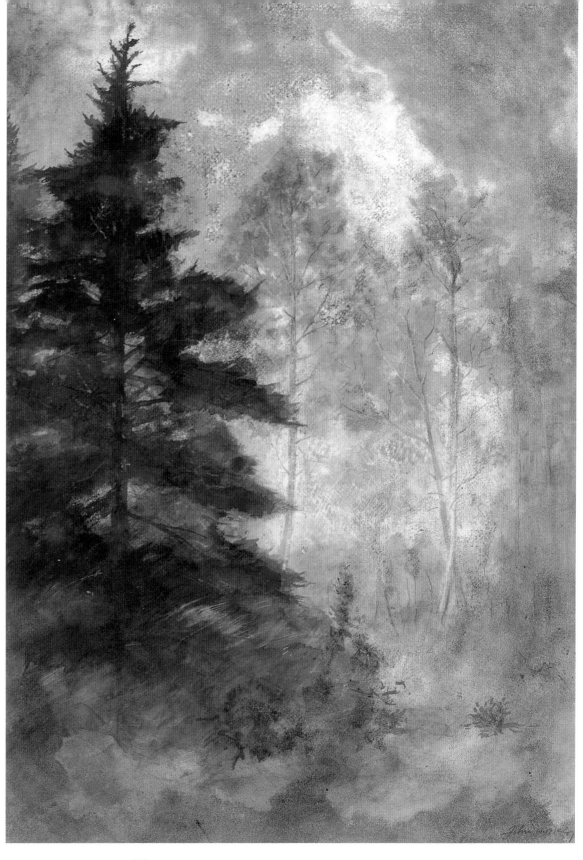

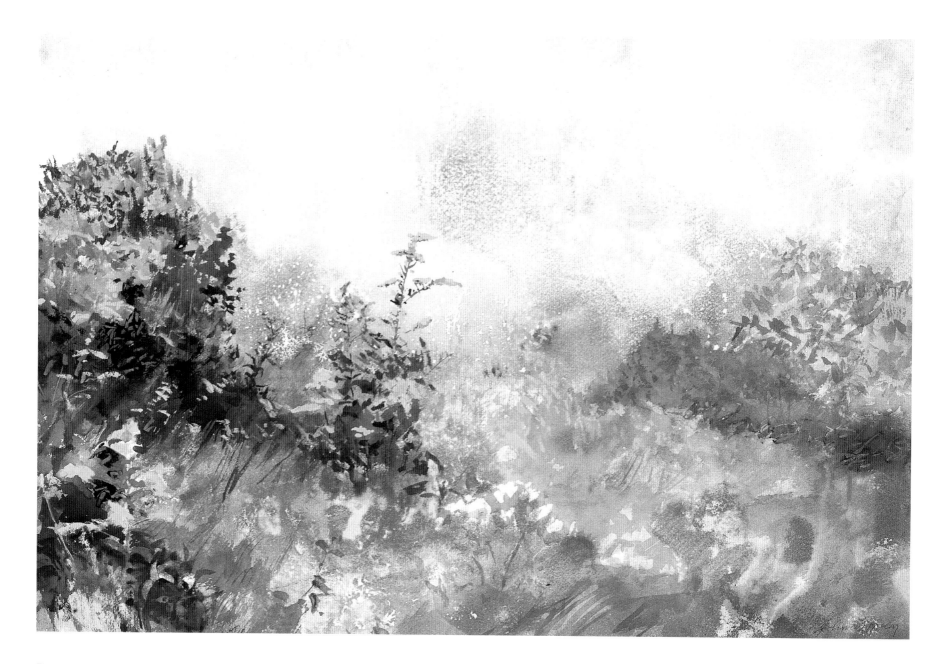

PLATE 42: Field Goldenrod, c. 1967
Mixed media on paper, 22 × 30 inches
Mr. and Mrs. Evans R. Jackson

McCoy used his mixed media again for the masses
of wildflowers that mark the end of the summer.
With paint and sponges he built and removed the
growth just as it had emerged and died back and
emerged again. In so doing, he seemed to act out
the lives of his subjects.

III

Resolutions

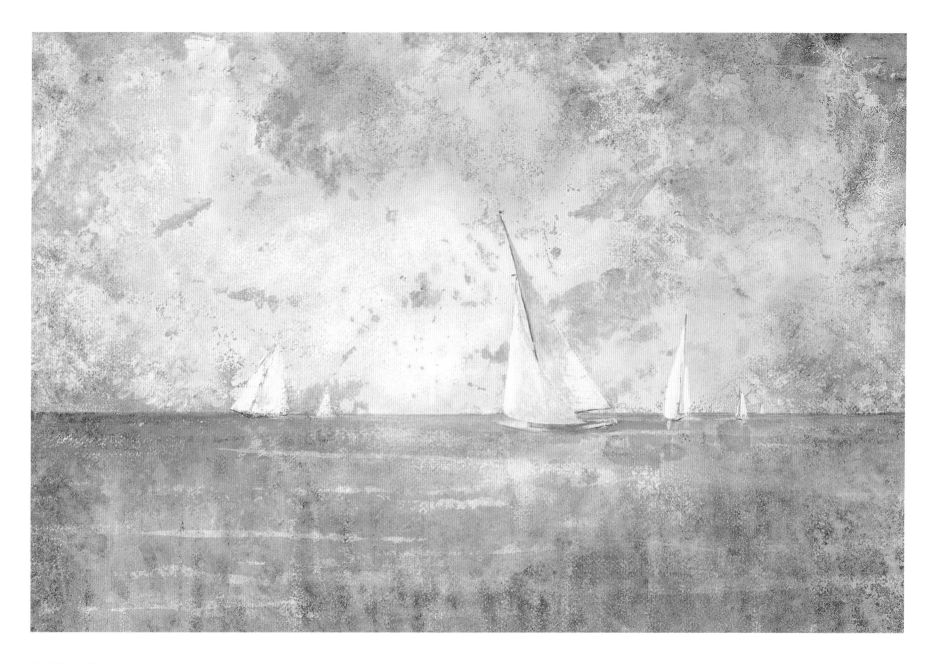

PLATE 43: Sailboats, c. 1968
Mixed media on paper, 22 × 30 inches
Mr. and Mrs. Jamie Wyeth

This is an extreme example of McCoy's mixed
media—a strange, almost harsh view of sailboats
instead of the usual, overly pretty scene. The artist
was not a sailor and, indeed, the "going in circles"
expressed here with the hot sky and flat water
says it all.

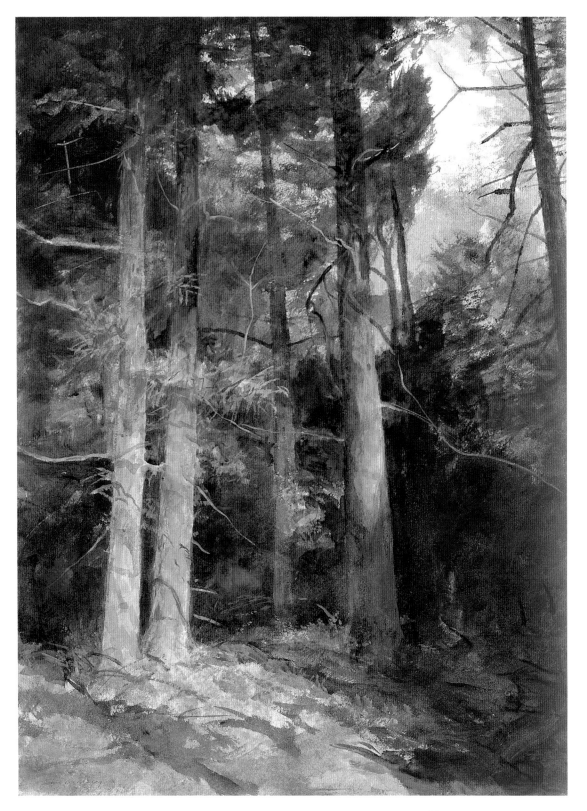

PLATE 44: Forest Light, c. 1970
Mixed media on paper, 30 × 22 inches
Ann Wyeth McCoy

Tall and dignified, always the gentleman, John McCoy seems to have painted his self-portrait here. Like him, these evergreens have the majesty of integrity. The painting was actually part of a triptych he had planned to name *Cathedral Woods*, but somehow the three works got separated. As one can see, however, each can certainly stand on its own.

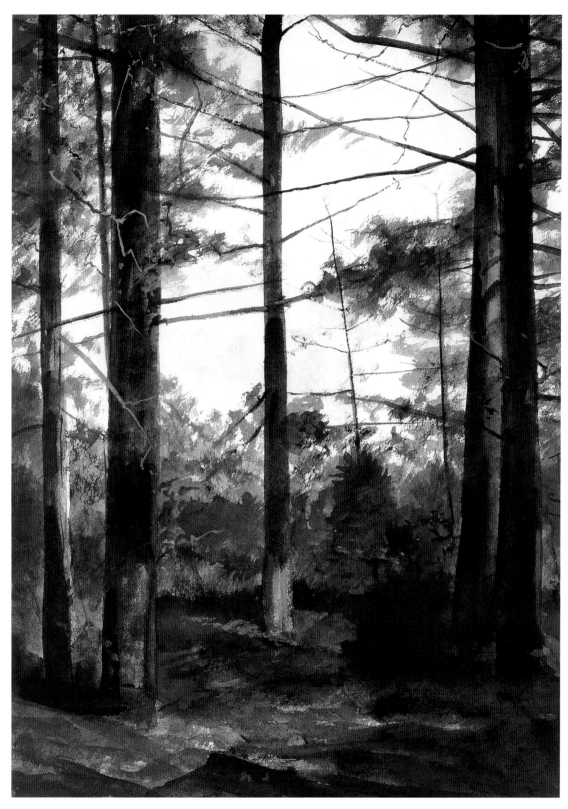

PLATE 45: Cathedral Woods, c. 1970
Mixed media on paper, 30 × 22 inches
Ann Wyeth McCoy

Like the other two paintings in the *Cathedral Woods* triptych, this one represents John McCoy's concept of a true place of worship.

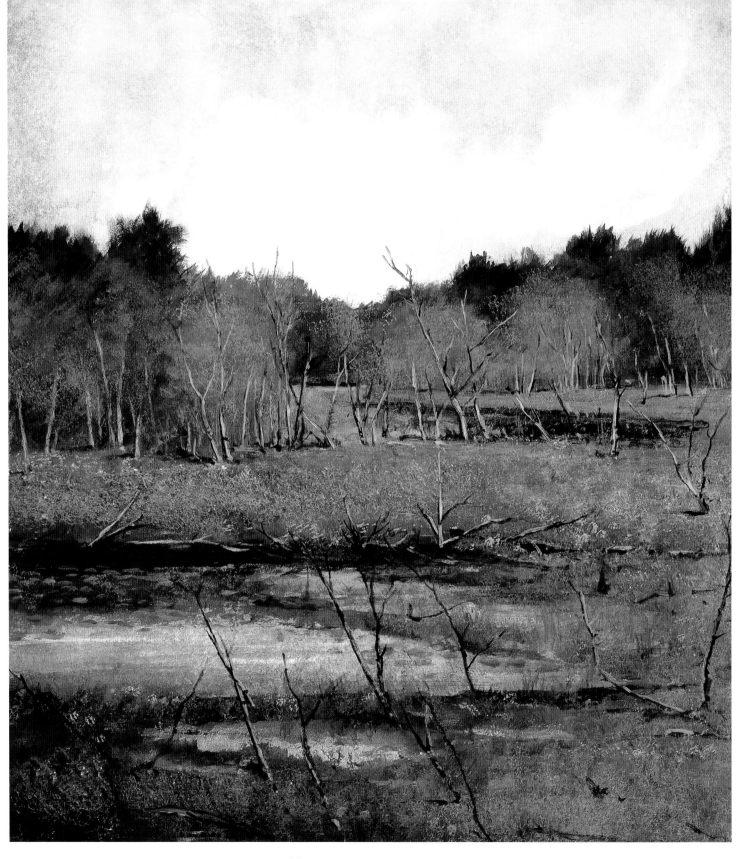

PLATE 46: Bog, c. 1970
Mixed media on paper, 24 × 18 inches
Ann Wyeth McCoy

On the way to the McCoys' summer house in
Maine there is a dip in the road, and if one looks
quickly to the left sometimes a moose or two can
be spotted in the bog. The magic of this place cer-
tainly captured the artist's attention, and he appre-
ciated it as another safe haven for wildlife.

PLATE 47: Delphinium, c. 1970
Mixed media on paper, 30 × 22 inches
Delaware Art Museum, anonymous gift

Flowers—in this case McCoy's own delphinium—
reach for the sky. Even though the artist was six
feet three inches in height, they towered over him.
His daughter Anna B. remembers asking him how
he was able to grow them so tall. She says he
replied with a wink that he watered them every
evening with a special brew. Again his wide choice
of media made it possible for McCoy to grasp the
intense blue of his flowers yet keep their fragility.

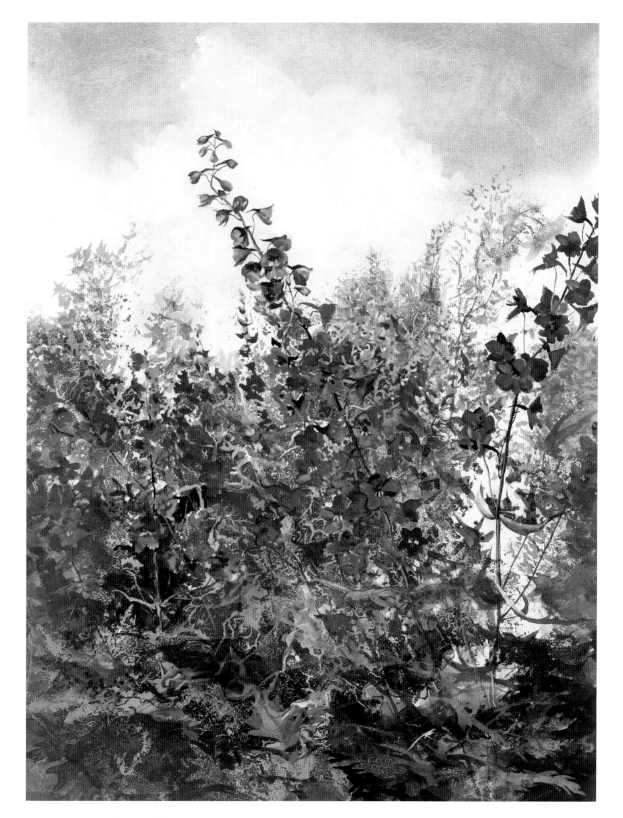

67

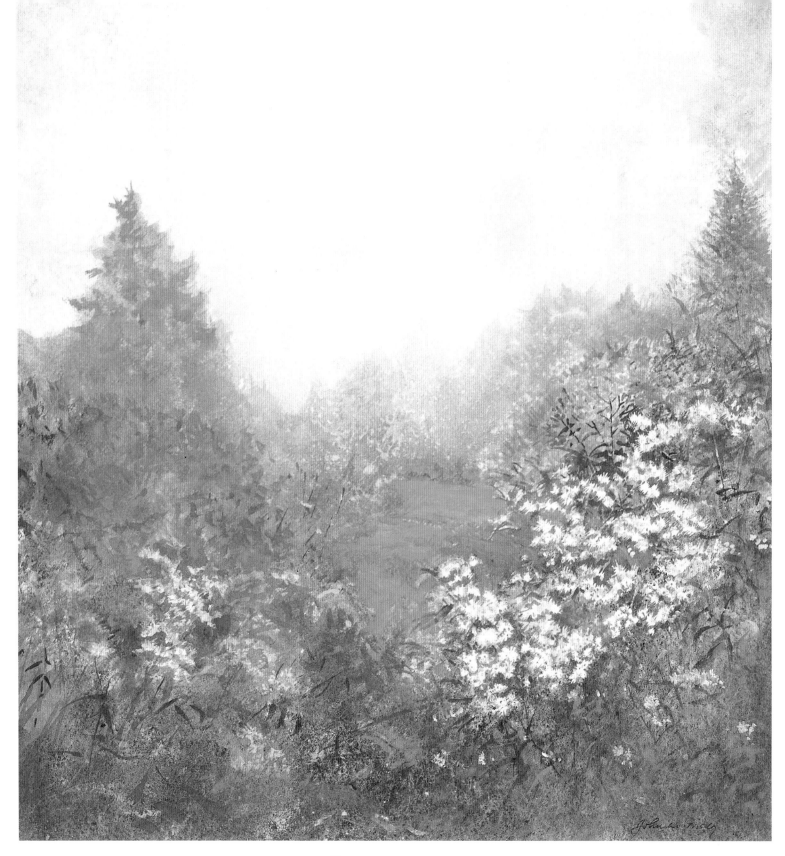

PLATE 48: Wildflowers, c. 1972
Mixed media on paper, 22 × 21 inches
private collection

In all of McCoy's works, he leaves a part of the
painting to the imagination. In his portraits, of
course, it is the character of the sitter. Here,
though the subject is wildflowers, the eye travels
back into the fog of the Maine coast. A wild animal
or bird could be foraging just beyond view. The at-
mosphere is filled with a mistiness that nurtures
this wonderful, flowering life.

PLATE 49: Landlocked, c. 1972
Mixed media on paper, 30 × 22 inches
Ann Wyeth McCoy

The oars left under this tree are useless but beauti-
ful. John McCoy often found meaning in everyday
discoveries. Again, the tree reaches for the sky,
which is filled with clouds approaching from over-
head. One can almost feel the curvature of the
Earth.

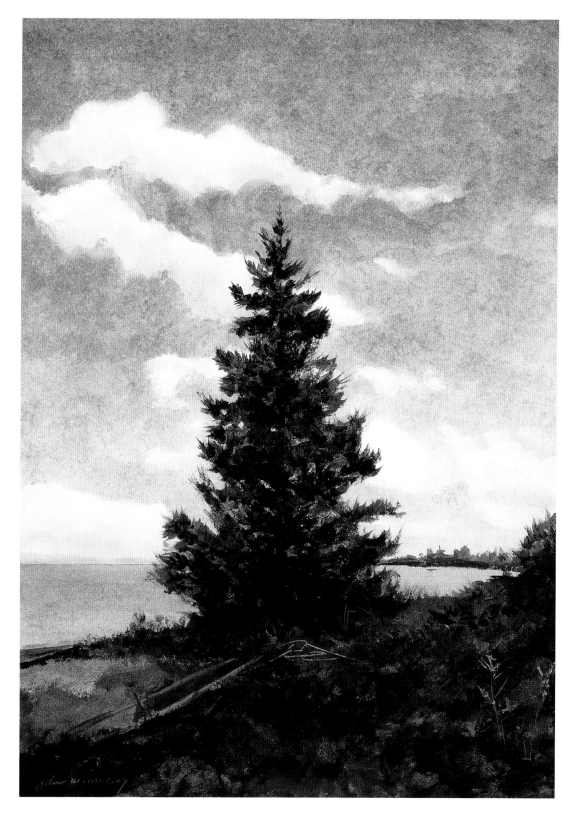

69

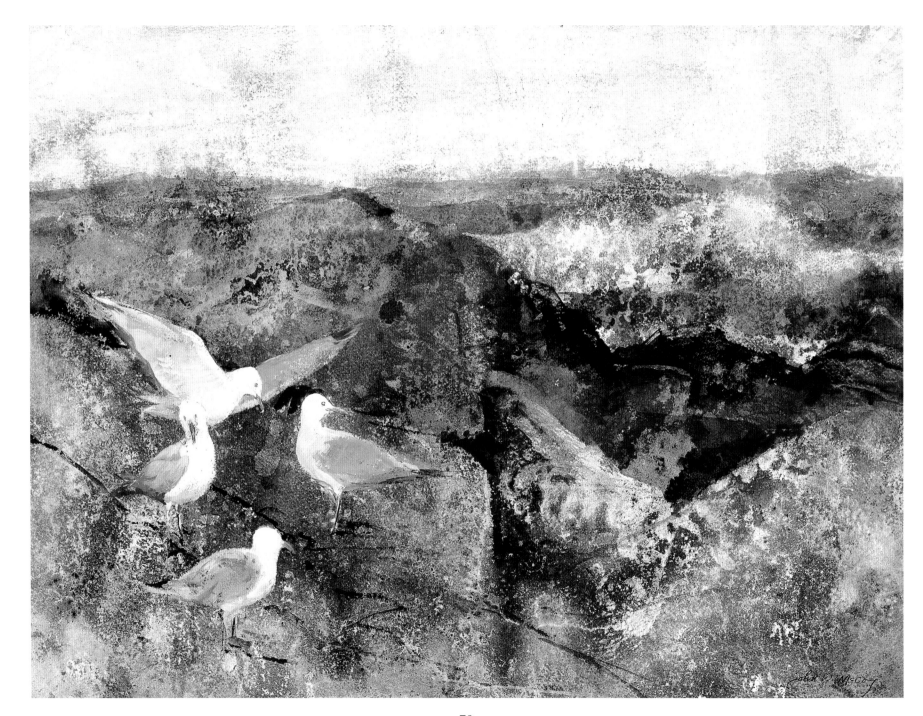

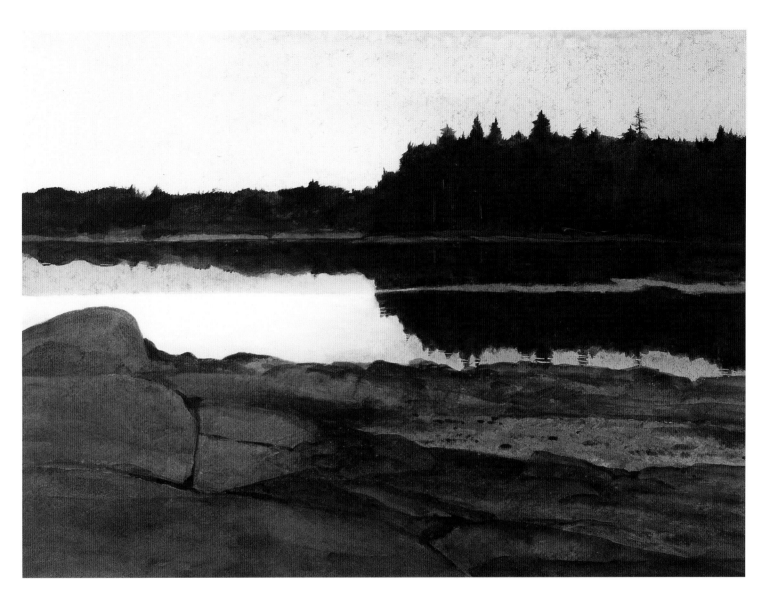

PLATE 51: Evening Tide, c. 1974
Mixed media on paper, 22 × 30 inches
Mrs. Jean Wyeth Bell

McCoy chose his medium according to the way he felt about the subject. This painting leans toward straight watercolor, with its clear definitions and more opaque colors. In contrast, *Refractions* (see Figure 6, page 7) shows the artist's complete abandonment to the accidents that can occur with mixed media.

PLATE 50: Four Gulls, c. 1971
Mixed media on paper, 22 × 30 inches
Private Collection

These birds seem to be having some sort of conversation, with the sea crashing just beyond them. Note the remarkable texture of the rocks, an effect that McCoy could achieve through his mixed media, using sponges, rags, and the interaction between oil and water. The rocks feel so rough compared to the soft, vulnerable breasts of the gulls.

71

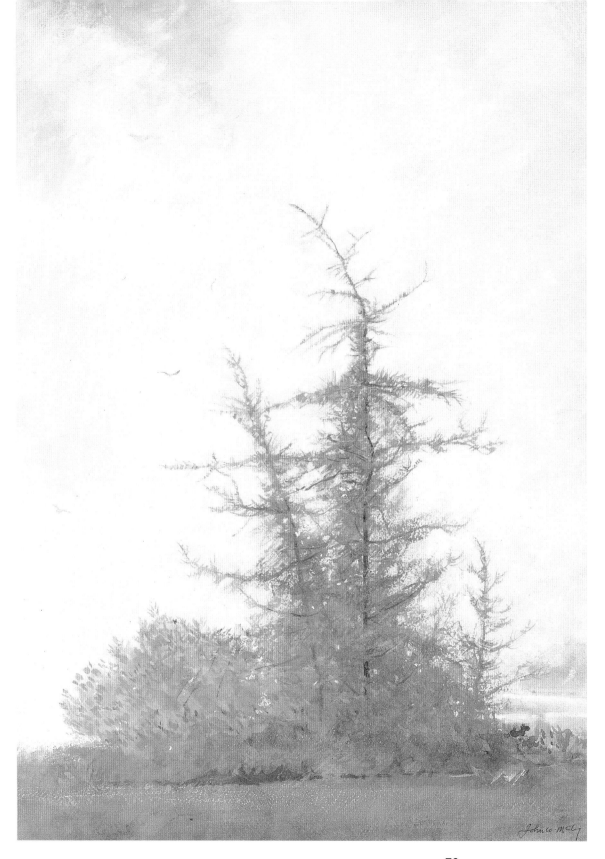

PLATE 52: Hackmatacks, c. 1974
Mixed media on paper, 30 × 22 inches
Ann Wyeth McCoy

McCoy made it look easy to capture the Maine coast and the oddly shaped trees that survive its harsh winds and cold temperatures. He was a master with the concept of "less is more."

PLATE 53: Surf at Southern Island, c. 1973
Mixed media on paper, 22 × 30 inches
Renée duPont Harrison

"Nobody does water like John" was a friend's remark whenever he looked at one of McCoy's river or sea paintings. This is a good example of the artist's fresh touch with surf and tide pools. Anna B. remembers her father watching the sea forever. No wonder he knew it so well.

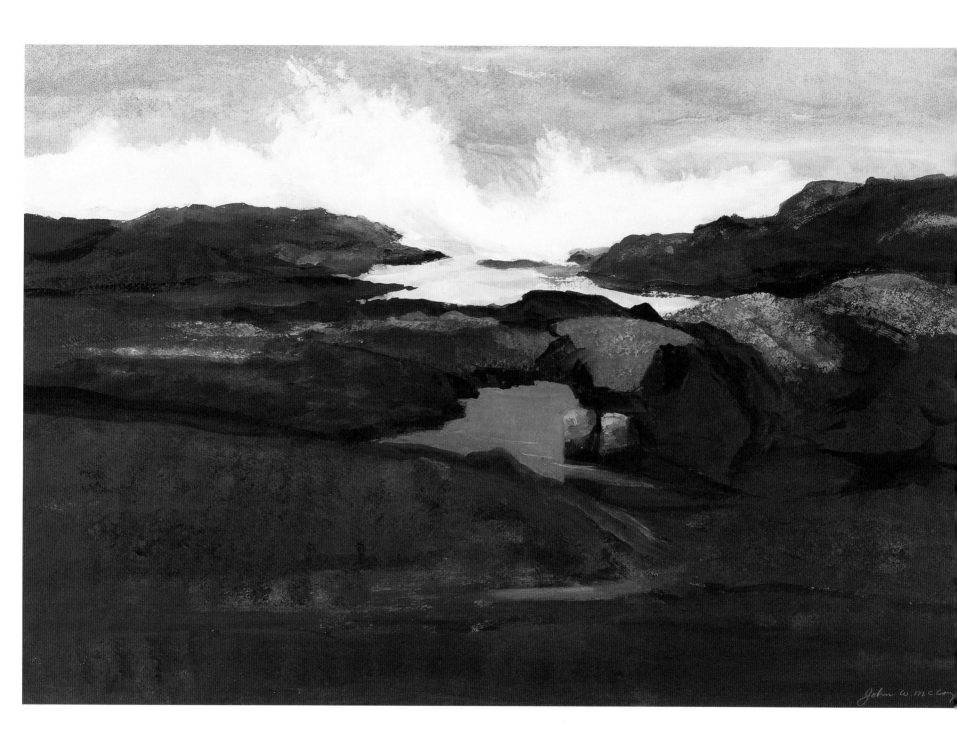

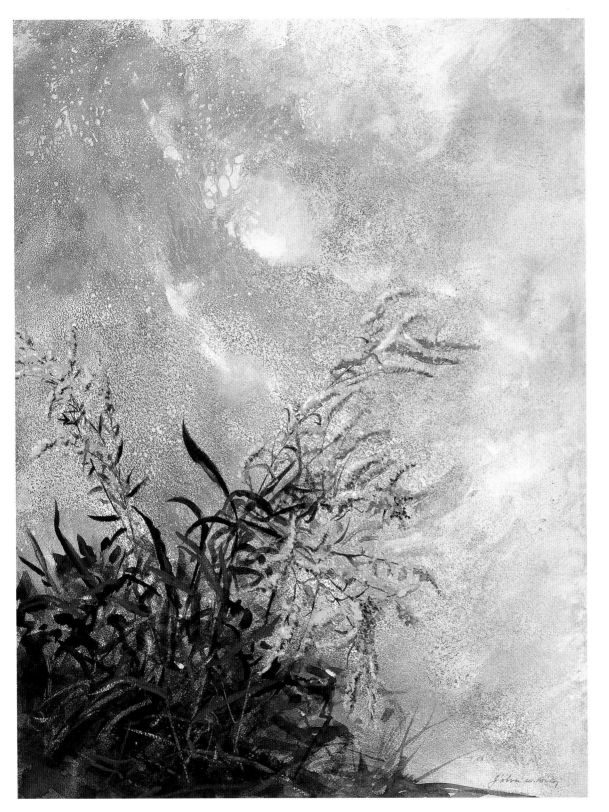

PLATE 54: Goldenrod, c. 1975
Mixed media on paper, 30 × 22 inches
Private Collection

This is really a painting of the wind. The goldenrod is being whipped around, as are the storm clouds. In McCoy's work, one always seems to be looking upward, toward the sky, from a low position. Perhaps this was the artist's unique view of the world.

PLATE 55: Moonflowers, c. 1975
Mixed media on paper, 22 × 30 inches
Sherry Kerstetter

These wild asters seem to be growing in space, against the moon, an effect that happened as McCoy soaked and played with his paper. He let it go, not trying to make complete sense out of it. The painting leaves one wondering—and feeling as though something very beautiful and unexplainable has just happened.

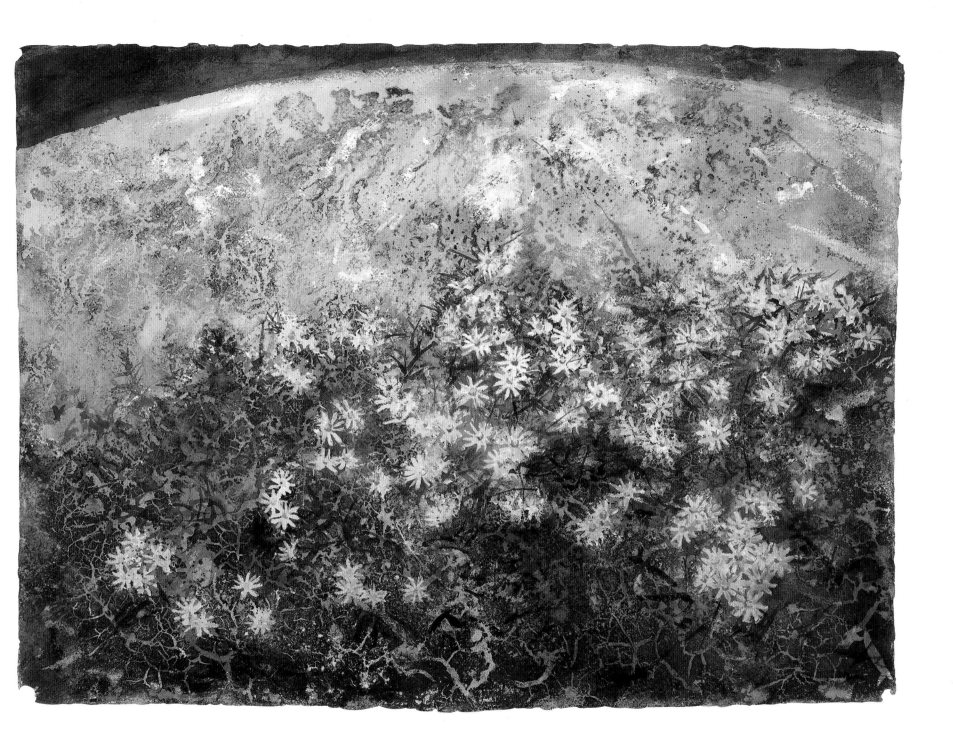

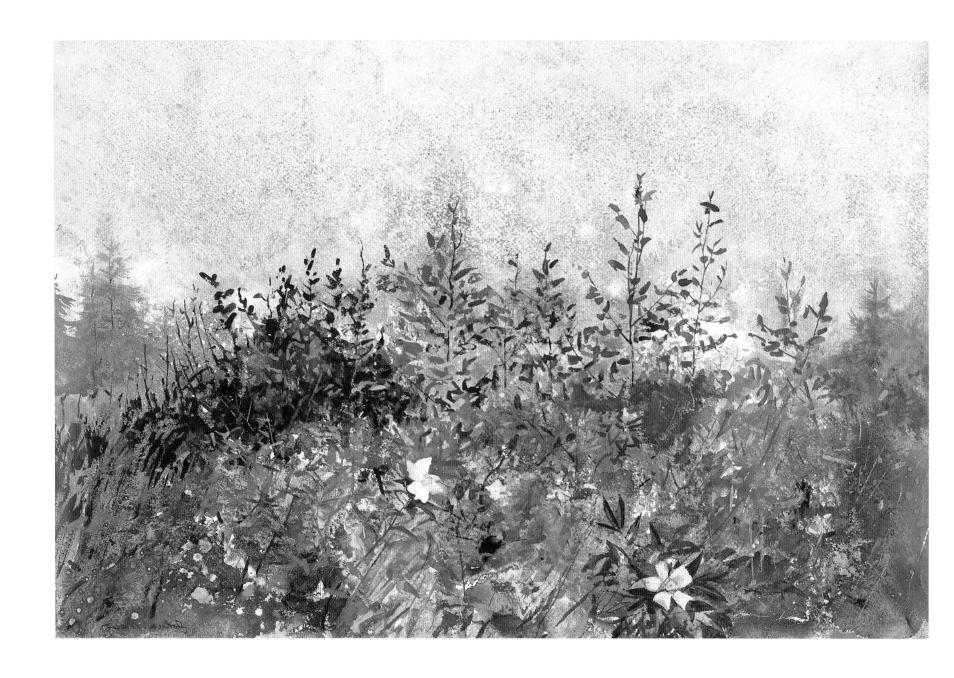

PLATE 56: Wild Roses, c. 1964
Mixed media on paper, 22 × 30 inches
Mrs. Jamie Wyeth

In this softly rendered painting of rugosa roses growing among the tangled weeds of the Maine coast, John McCoy has shown that these plants are delicate, yet tough enough to survive along the crowded banks of the coves and inlets that border the sea.

PLATE 57: Cold Front, c. 1975
Oil on canvas, 46¼ × 32 inches
Robin McCoy

When McCoy returned to oils, he was so influenced by his mixed media that he worked with the paint in a very loose way. This gives his rendering of a back cove in Maine a movement and power that can take one's breath away. The artist loved the cloud formations that happen near the water, and he painted them with expertise and much passion.

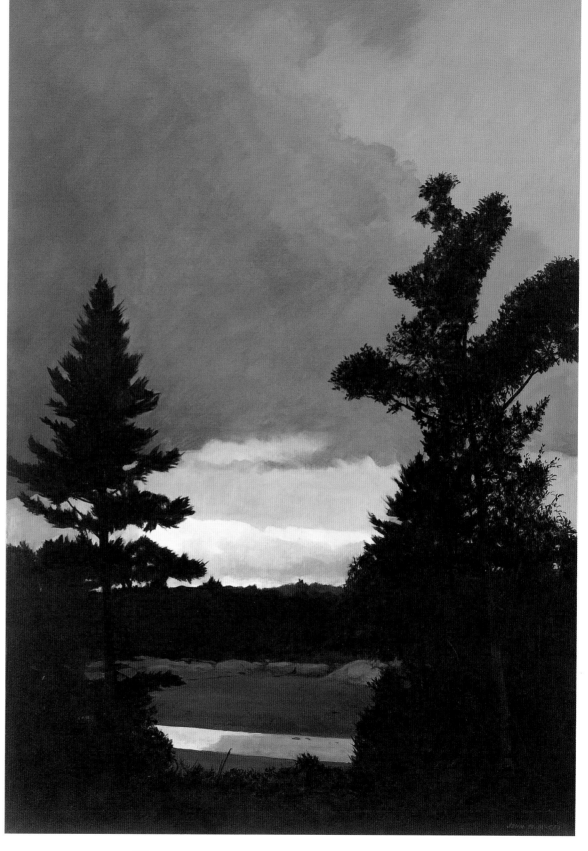

77

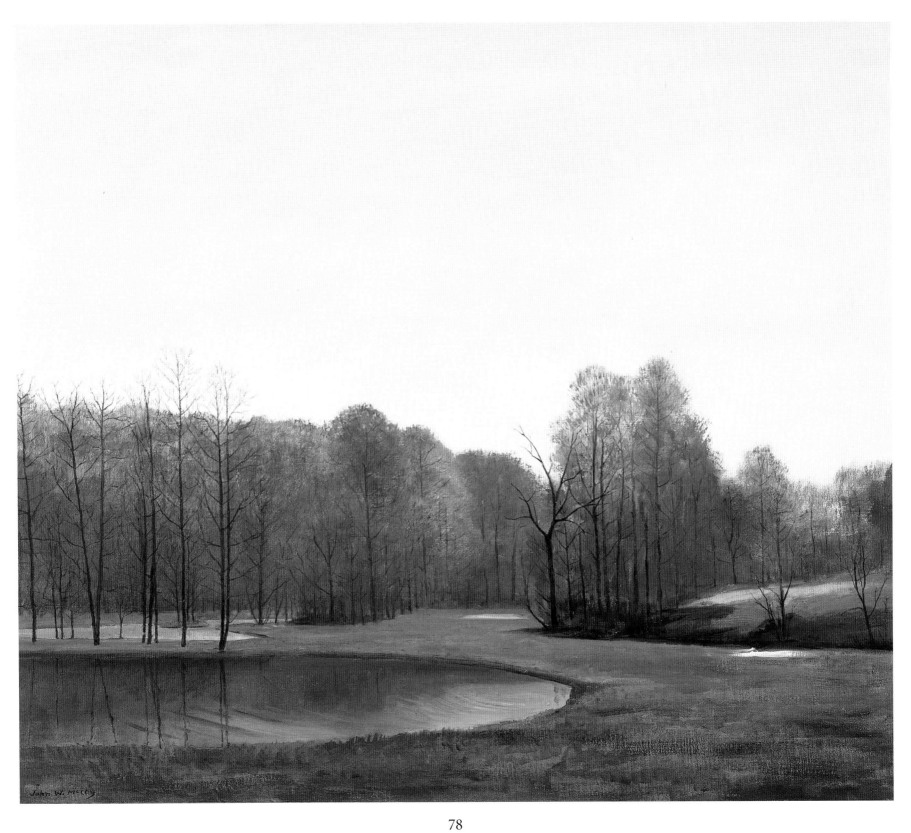

John W. McCoy

PLATE 58: Early Spring, c. 1975
Oil on canvas, 34 x 41 inches
Anna B. McCoy

This large painting depicts the view from McCoy's beloved terrace in Pennsylvania. Here he watched for deer, birds, and the changing seasons from a perch halfway up the hill, where his house was. He never tired of this view nor of recording it.

PLATE 59: Witch Corner, 1976
Mixed media on paper, 30 x 22 inches
Farnsworth Art Museum, anonymous gift in memory of Wendell Hadlock

Bringing in a contemporary, manmade element like a car's approaching lights is an important touch in this lonely, haunting painting. McCoy's daughter Anna B. explains, "*Witch Corner* is such a great name because it evokes wonderful memories of us walking home alone in the dark, feeling as though there were something lurking just beyond our vision at every turn. My father's penchant for telling spooky tales is very much a part of this painting, as is his respect for the old superstitions and the traditions of the surrounding countryside."

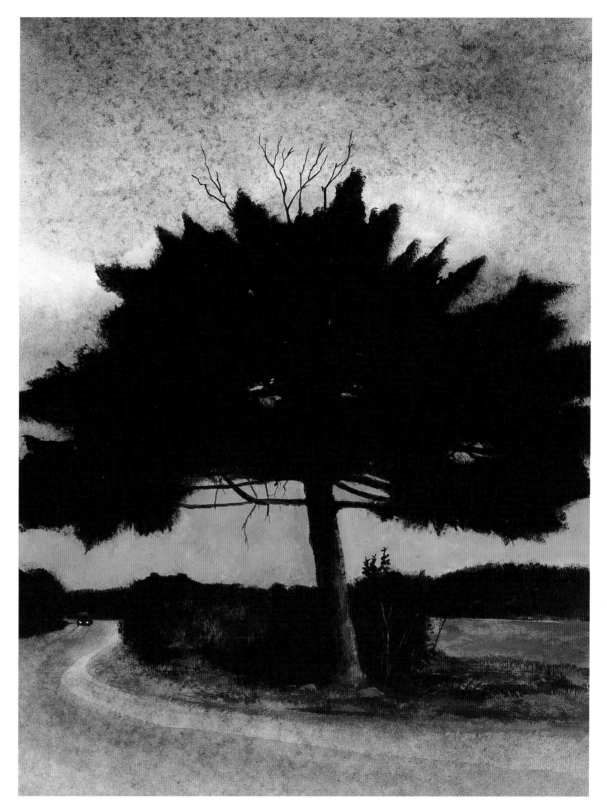

79

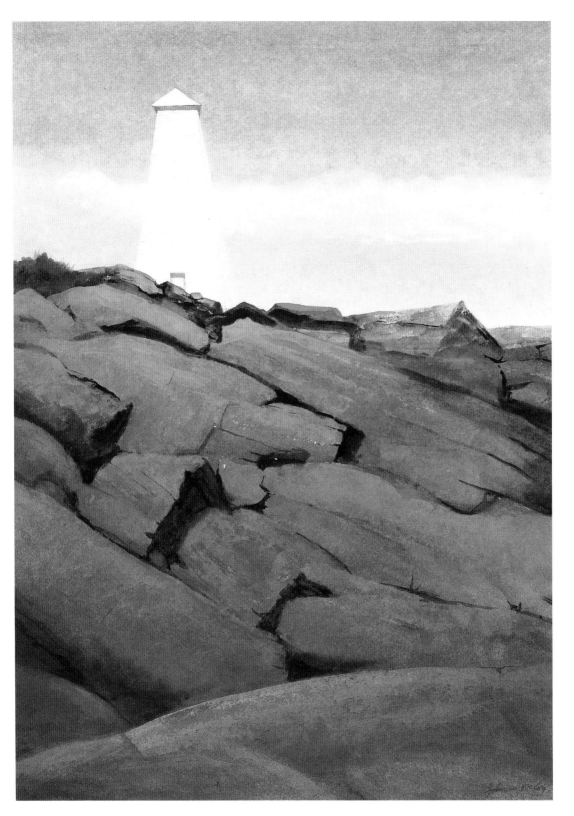

PLATE 60: Mirage, c. 1977
Mixed media on paper, 30 × 22 inches
Ann Wyeth McCoy

Here again is McCoy's playful yet serious feeling for the spiritual side of life. He is looking up across a rocky shore to a bell tower silhouetted against the sky, partially hidden by cloud cover. Did he actually see such a sight or simply imagine it?

PLATE 61: Winter of '78, 1978
Oil on canvas, 32½ × 44½ inches
Denys McCoy

This large painting is one of John McCoy's last oils. Appropriately, it teems with the fury of the wind and snow and clouds. The artist loved all these inevitable turns of Nature. He expressed them well, using his oils with passion.

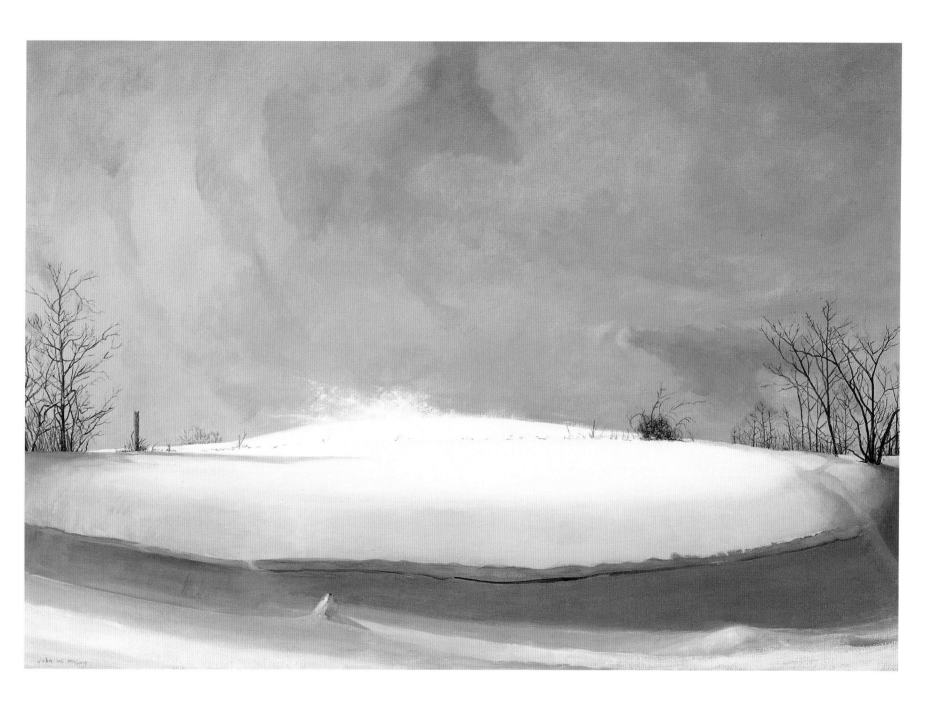

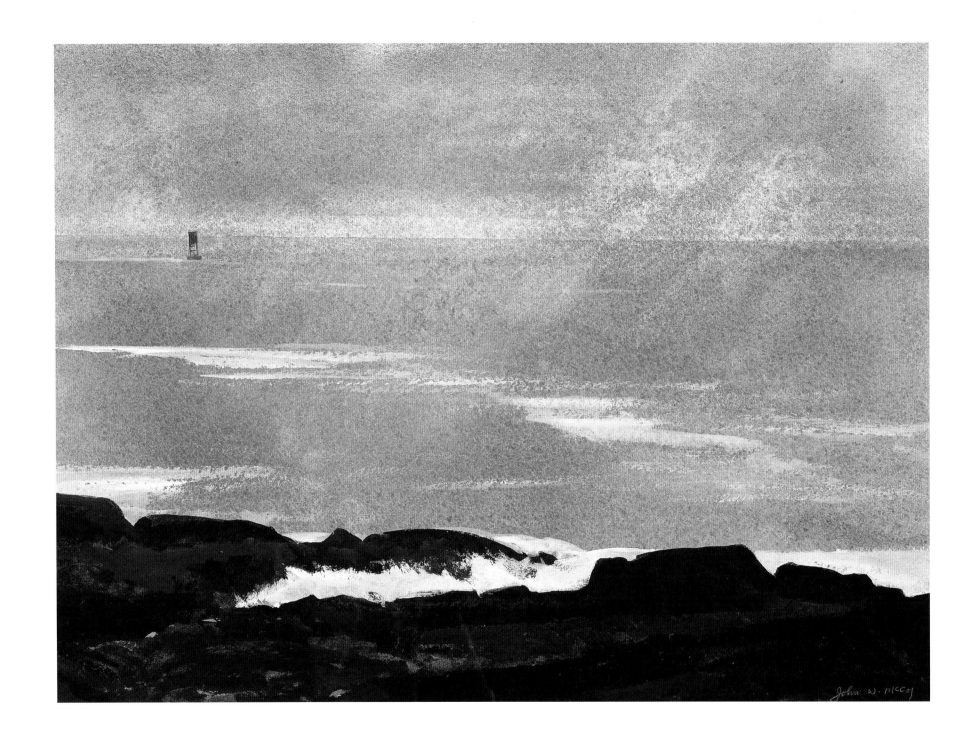

PLATE 62: Bell Buoy off Tenants Harbor, c. 1980
Mixed media on paper, 22 × 30 inches
Ann Wyeth McCoy

The sound of a bell buoy ringing off the coast was a familiar one for the artist during rough weather. He loved it, and here he expresses that love with all the loneliness the sound elicited. The mixed media was perfect for creating the feeling of a rainy day with a bit of surf.

PLATE 63: Columbine, c. 1981
Mixed media on paper, 30 × 22 inches
Mr. and Mrs. Richard S. Burroughs

The flowers that McCoy loved to grow were his constant subjects. He no doubt saw them as a miracle of Nature, and that is exactly what one feels when looking at this painting. The flowers seem to float on their long, thin stems—almost like fireworks going off in the evening sky.

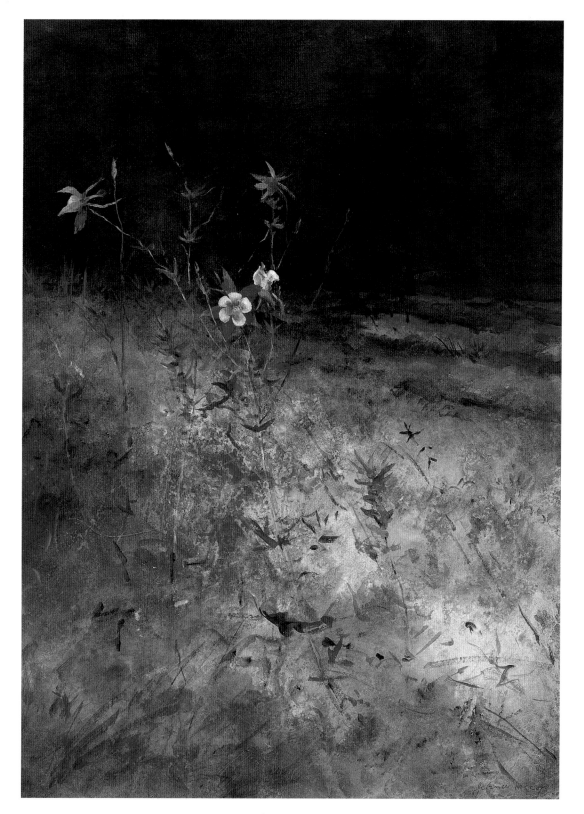

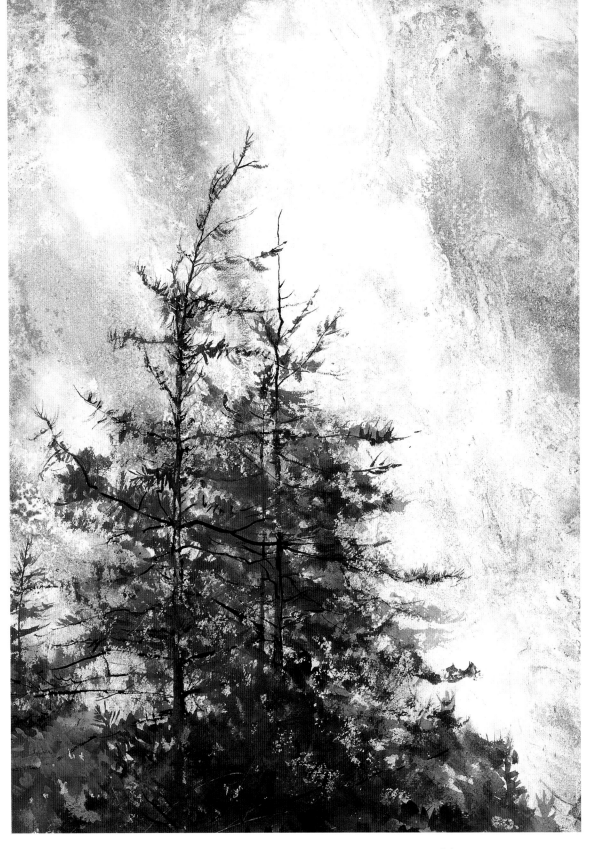

PLATE 64: Ascending Clouds, c. 1982
Mixed media on paper, 30 × 22 inches
Ann Wyeth McCoy

By the time he made this painting, John McCoy was suffering from Alzheimer's disease. He expressed his anguish through the tumultuous skies and wind-racked trees. He could no longer control the chaos without or within.

PLATE 65: Thunderclouds, c. 1982
Mixed media on paper, 30 × 22 inches
Margaret Fields

This was one of McCoy's last works. It certainly
foretold the approaching storm.

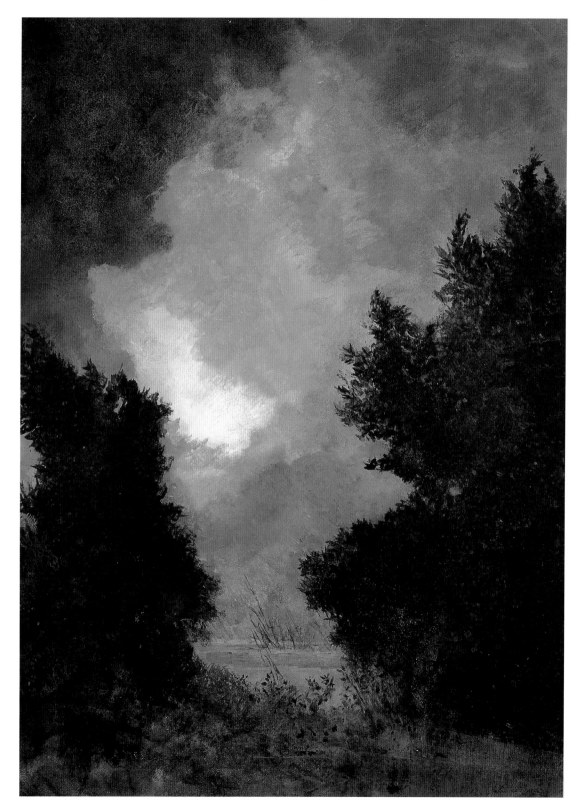

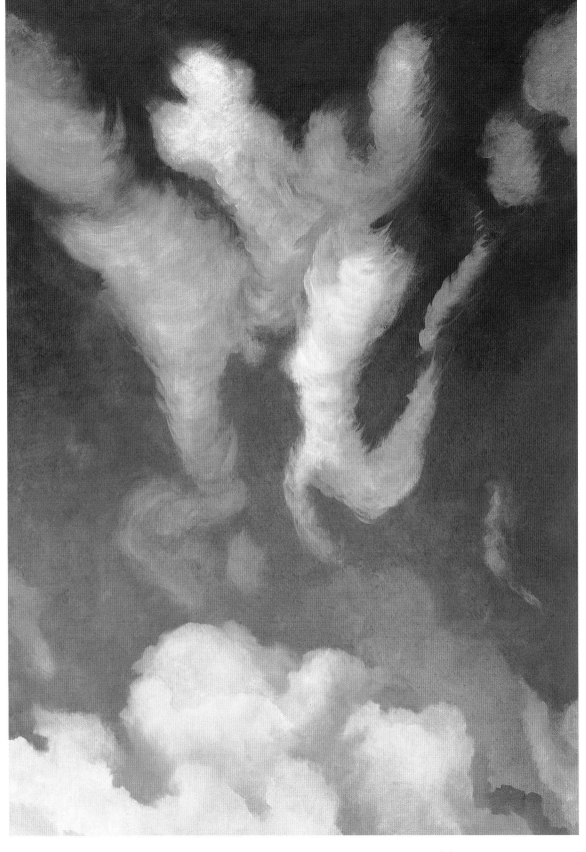

PLATE 66: Clouds, undated
Oil on canvas, 40 x 30 inches
Tower Hill School, in memorium for
W. Brook Stabler

It is fitting to end with this monumental oil, for it
is a symbol of McCoy's longing to be one with the
skies and their clouds.

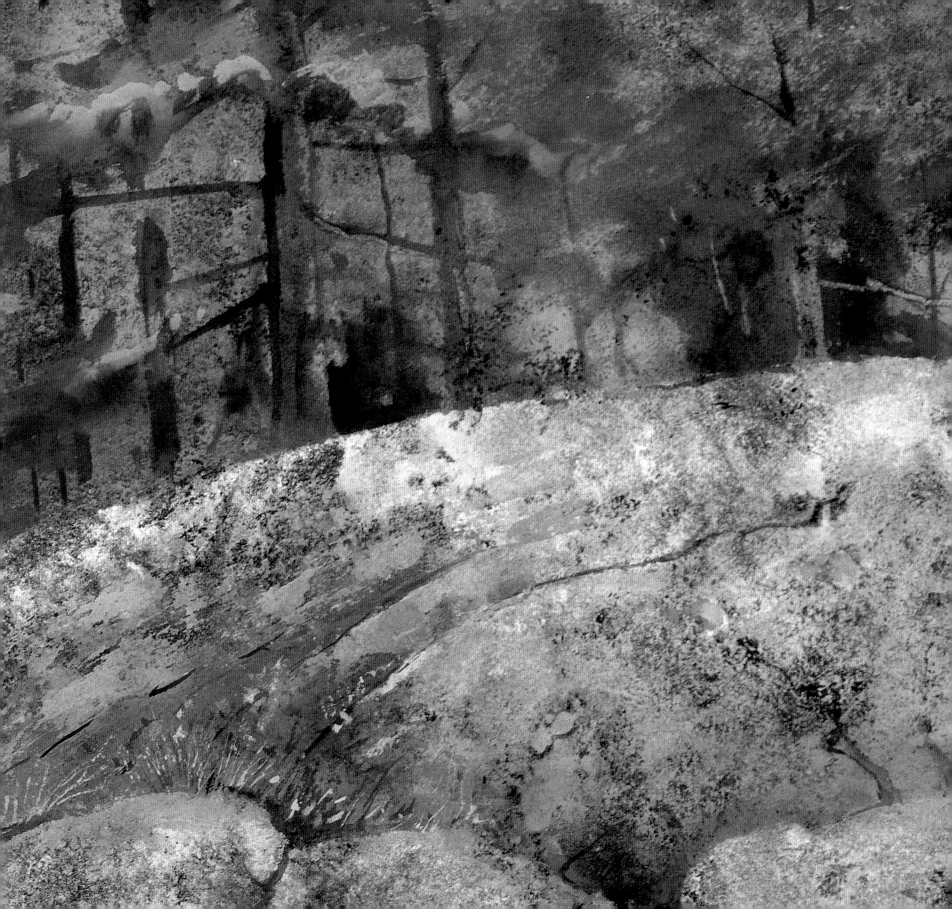